SHEFFIELD AT WORK

MELVYN & JOAN JONES

AMBERLEY

Front cover: Sheffield Forgemasters' 10,000-ton forging press shaping a 250-ton ingot. (Courtesy of Sheffield Forgemasters International Ltd (Billy Greenhalgh))

First published 2018

Amberley Publishing
The Hill, Stroud
Gloucestershire, GL5 4EP

www.amberley-books.com

Copyright © Melvyn & Joan Jones, 2018

The right of Melvyn & Joan Jones to be identified as the Authors of this work has been asserted in accordance with the Copyrights, Designs and Patents Act 1988.

ISBN 978 1 4456 7753 8 (print)
ISBN 978 1 4456 7754 5 (ebook)

British Library Cataloguing in Publication Data. A catalogue record for this book is available from the British Library.

Origination by Amberley Publishing.
Printed in the UK.

CONTENTS

ACKNOWLEDGEMENTS

The authors would like to thank the following for the donation or loan of photographs, drawings and/or accompanying information: Atkinson's Department Store (David Cartwright), Mary Bulmer, Burgon & Ball (Alison Edwards), the Company of Cutlers in Hallamshire, John Greaves, Helen Jackson, June Limb, Trevor Lodge, Peter Machan, Meadowhall Leisure Shopping, Millennium Galleries, Newton Chambers Co. Ltd, Sheffield Assay Office, SCX Group Ltd (Darren Falkingham), Sheffield Forgemasters International Ltd (Billy Greenhalgh), Sheffield Local Studies Library, Sheffield Newspapers, Tanya Schmoller, Cyril Slinn, Stocksbridge Local History Society, Swann-Morton Ltd (Chris Taylor), Bob Warburton and A. R. Wentworth Sheffield Ltd.

INTRODUCTION

Sheffield has been dubbed 'Steel City' but as will become clear, it is much more than that. Sheffield grew prodigiously during the nineteenth century from an already substantial 91,000 in 1831 to over 400,000 by 1901 as a result of industrial expansion. But for centuries before that it had had a national reputation for its industrial products. Everyone knows the famous line from Chaucer's *The Reeve's Tale* written around 1390 about the miller, stating that 'A Scheffeld thwitel baar he in his hose'. A 'thwitel' was a knife and Chaucer obviously believed that mention of a Sheffield knife would be as familiar then as a Cornish pasty is today. Nearly 400 years later in 1779 Charles Burlington in *The Modern Universal Traveller* wrote that Sheffield was 'the most remarkable place in England for cutlerywares'. During the nineteenth century the light steel trades continued to flourish in the town and in the surrounding villages and were joined by a completely new industry: heavy steelmaking and heavy engineering. This transformed the former mainly rural Lower Don Valley to the east of the old town.

Industrial growth had its negative effects. As early as the 1720s Daniel Defoe in *A Tour thro' the Whole Island of Great Britain* wrote that the streets were narrow and the houses 'dark and black, occasioned by the continued Smoke of the Forges, which are always at work'. Even more evocative was J. B. Priestley's comments in his *English Journeys* in 1933. He said that when he approached the city from the south it 'looked like the interior of an active volcano', adding that the smoke was so thick that it appeared the descending streets 'would end in the steaming bowels of the earth'.

And yet today Sheffield has the reputation of being the country's greenest city. It had one of the country's first green belts (1938) and 39,000 acres of the Peak District National Park lie within its boundaries. The city contains nearly eighty ancient woods and is the best wooded city in the country. And what is astonishing is that the woods have survived because of their connection with local industry (see chapters 'In the Beginning…' and 'The Seventeenth and Eighteenth Centuries: Invention and Change').

Today Sheffield is a prime example of a post-industrial city. Its two universities attract more than 60,000 students to the city every year; the Lower Don Valley, described in the 1970s as an industrial wasteland, is now crowded with edge-of-town shopping, entertainment and sporting destinations. The Heart of the City scheme has also helped to modernise the city centre with its Winter Garden, Millennium Galleries, new hotel and water features. But manufacturing still continues from large works like Sheffield Forgemasters, which supplies

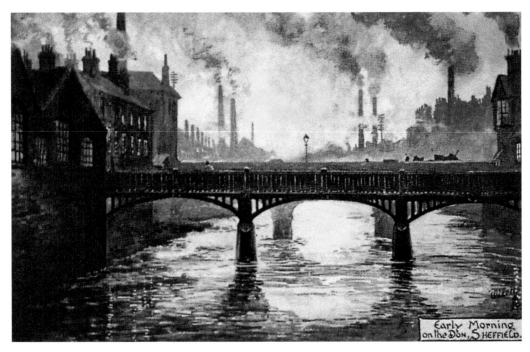

Early morning on the Don in the early twentieth century.

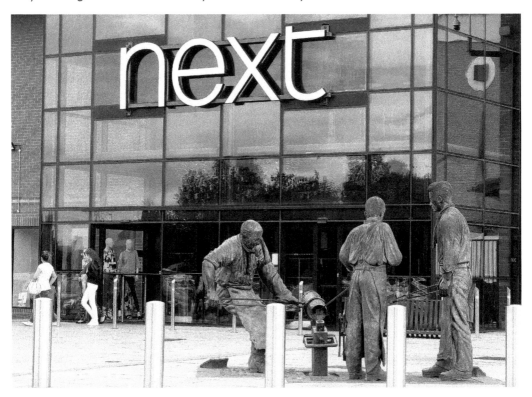

Crucible 'teemers' outside Meadowhall Shopping Centre.

forged and cast steel to the engineering, nuclear and petrochemical industries worldwide, and Liberty Steel at Stocksbridge, which produces special steels for the aerospace, oil and automotive industries. And another Sheffield engineering firm, SCX Group, has completed the second year of a three-year project to construct a foldaway roof for No. 1 Court at Wimbledon, which will be ready in 2019; they constructed the retractable roof on Centre Court in 2009. At the other end of the scale individual craftsmen, known locally for centuries as 'little mesters', still produce knives and other bespoke products in small workshops. And a surprising number of small- and medium-sized firms continue the centuries-old tradition of manufacturing a wide range of metal products.

Against this background the book is organised chronologically in six chapters covering nine centuries and emphasising the combination of continuity and innovation that has characterised the evolution of employment in industry and other occupations in the city.

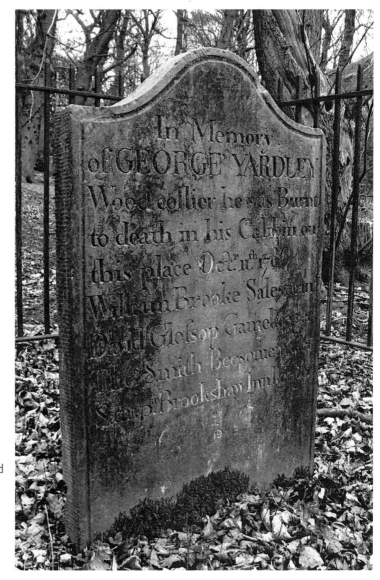

Monument to George Yardley, wood collier (charcoal maker) in Ecclesall Woods. He was burnt to death in his cabin on 11 October 1786.

IN THE BEGINNING...

Sheffield began life as a town rather than a village under its Norman lords. The Norman town was established immediately to the south-west of the confluence of the rivers Don and Sheaf where, in the twelfth century, William de Lovetot built a motte-and-bailey castle with a stone and timber keep. The castle defended the entry from Sheffield over the River Don from the north. The two rivers formed a natural moat to the Norman castle on the north and east. This motte-and-bailey castle, which had descended to the de Furnival family at the end of the twelfth century, was destroyed by fire in the second half of the thirteenth century during the Barons' Revolt and was replaced, by Thomas de Furnival, with a stone keep and bailey castle around 1270. This stone castle was largely demolished in the late 1640s by Cromwell's government following the Civil War when it was garrisoned for the king until it surrendered in 1644. Following its demolition it was plundered by the local population for building stone and other buildings occupied the site.

At its greatest extent this outer bailey is thought to have run south from the moat up the slope as far as the modern Fitzalan Square. Thomas Winder, who worked for many years in the Duke of Norfolk's estate office in Sheffield, put together a sketch map of the castle site based on old maps he had consulted. The map shows a square hill on which the keep was located, the moat south and east between the Don and Sheaf, and the close relationship between the keep and the entry into the town across the River Don via Lady's Bridge.

The medieval market town of Sheffield grew up under the protection of the castle. In 1281 Thomas de Furnival was asked by a royal enquiry into the rights of landowners on what grounds he believed he had the right to hold a market in Sheffield, and he replied that his ancestors had held it since the Norman Conquest. He put this right to hold a market on a more formal footing fifteen years later when in 1296 he obtained a royal charter for a market every Tuesday and a fair at the Feast of Holy Trinity.

Beneath the castle walls in a tight cluster of narrow streets including what is the modern Market Place, Haymarket (formerly called the Beast Market and before that the Bull Stake), Waingate (formerly called Bridge Street), Castle Green, Castle Folds, Dixon Lane, Snig Hill, and the now lost Pudding Lane, Water Lane and Truelove's Gutter (which was also an open sewer) lay the oldest part of the town. Surviving documents from the late sixteenth century give the impression, 500 years after its first creation, of a tight-knit collection of houses, cottages and shops with their outbuildings, gardens, crofts and yards.

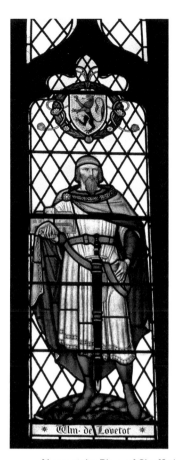

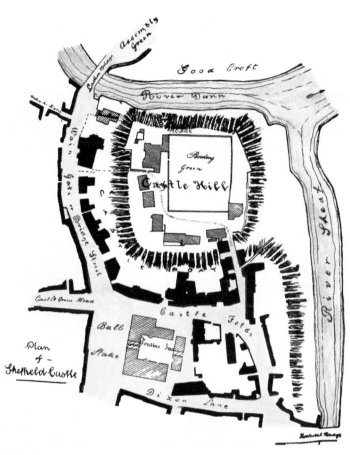

Above right: Plan of Sheffield Castle.

Above left: William de Lovetot.

The central area immediately to the south and west of the castle was the town's main retail area. A rental of 1581 itemises eight shops under and around 'ye Court Chamber', which was another name for a market hall with a room at first-floor level but open underneath. The 1581 rental also describes four 'payntesses' and 'stannedges' near the courthouse. A payntess was a shed attached to a building and stannedge was probably a 'standing', so these appear to have been market stalls probably with wooden shutters that could be opened upwards to form a protective awning and downwards to form a display counter. In 1581 one of the stalls was held by a fishmonger and three by tanners selling leather, which was used in a wide variety of ways – not only for boots and shoes but also for harnesses, saddles, breeches, aprons, gloves and mittens, bellows, bags and bottles. Nearby were twelve butchers' shops, two of them said to be new and three of them in the 'shamblehowse' (the meat market). Here too was the market cross and the Bull Stake where the town bull may have been tethered for hire. In nearby Pudding Lane, a narrow lane between the Market Place and the Bull Stake (Beast Market), was the public bakehouse, from where as late as 1609 one of the 'paynes' (by-laws) agreed by a jury at the manorial court stated that all the householders within the town of Sheffield should bake their bread.

Above: An early engraving of Lady's Bridge built in 1486, now hidden below the modern bridge.

Left: The Market Cross.

From this central core beneath the castle walls the town spread out in all directions. To the east along what became known as Dixon Lane the way led to the River Sheaf where a stone bridge was built in 1596 and which led to the castle orchards. To the south-west the town spread along what is the modern High Street but what until the late eighteenth century was known as Prior Gate because it contained properties belonging to Worksop Priory. Beyond High Street was a lane that became known as Fargate (gate is from *gata*, the Danish Viking word for a lane). Along both sides of High Street and the southern side of Fargate today can still be seen the evidence of the late medieval and early modern expansion of the town in the form of long narrow building plots sometimes separated by long alleys, such as Change Alley, Mulberry Street and Chapel Walk. The long building plots in medieval towns are called burgage plots because they were occupied by the citizens (burgesses) of the town and reflect the desire to allow as many shop, workshop and other workplace owners to have a commercial frontage on a main street. It would not be announced in words what was made

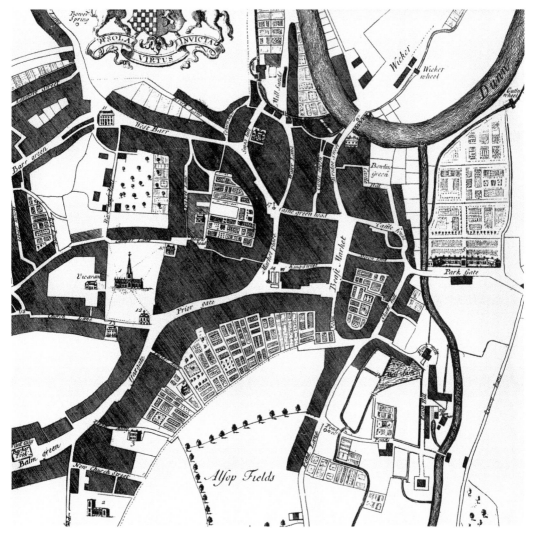

Sheffield as shown on the first known map of the town by Ralph Gosling, dating from 1736.

Chapel Walk today occupying a burgage plot boundary.

or sold there. Instead there would have been signs or symbols, of which only pub signs and the barber's red and white pole remain in use today. Northwards from the central core was Snig Hill. The probable meaning of the word 'snig' is for a block of wood that was put through cartwheels to act as a brake, and as Snig Hill led to the town's manorial corn mill at Millsands, many a heavy load must have had to be braked on the steep hill.

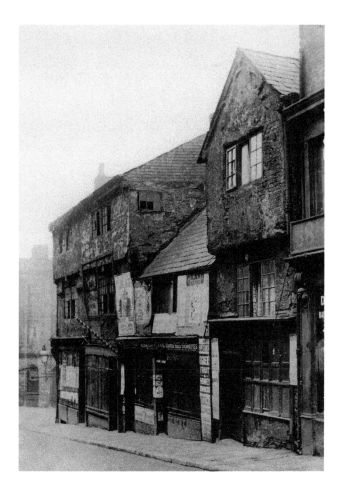

Snig Hill in the late nineteenth century.

No one knows when the light steel trades of Sheffield were born. There is a reference as early as 1297 in the tax returns of Robertus le coteler – Robert the cutler of Sheffield. By the late fourteenth century, around the time that *The Canterbury Tales* were being written, there were a good number of references to cutlery making and allied trades. In the Poll Tax Returns of 1378–79 for Sheffield and Handsworth, for example, twenty smiths were listed together with three taxpayers – Thomas Byrlay, Jonannes atte Well, and Thomas Hank – who were specifically described as cutlers. In neighbouring Ecclesfield, six smiths were listed together with Ricardus Hyngham, 'cutteler', and Johannes Scot, 'arismyth' (arrowsmith).

By Elizabethan times the town had overtaken its provincial rivals at Thaxted in Essex and Salisbury in Wiltshire and lay second only to London in cutlery manufacture. The term cutlery embraced not only the making of knives but also other articles with a cutting edge such as scissors, shears, sickles and arrows. There are several convincing literary references to the importance and reputation of Sheffield's cutlery manufacturers; for example, John Leland, the topographical writer who visited Sheffield in 1540, wrote that 'Ther be many smithes and cutelars in Hallamshire.' And in 1569, the 6th Earl of Shrewsbury wrote to Lord Burghley, Queen Elizabeth's Secretary of State, informing him that he would be receiving 'a case of Hallamshire whittells, being such fruictes as my pore cuntrey affordeth with fame throughout

this realm'. In a similar vein Peter Bales in his *Writing Schoolmaster*, published in 1590, put his praise of Sheffield in verse in his chapter on choosing a penknife:

> *First then be your choice of penknife!*
> *Provide a good knife; right Sheffield is best.*

As the cutlery trades of Sheffield and its surrounding area developed rapidly in the sixteenth century they came under the regulation of the manorial courts, which dealt with matters such as apprenticeships, the issuing of trademarks, the drawing up and supervision of work practice regulations and the settlement of disputes. There was, therefore, an organisational, and in many respects restrictive, framework within which the growing industry operated, together with the personal interest and patronage from successive lords of the manor, particularly from the 6th Earl of Shrewsbury (lord of the manor between 1560 and 1590), and the 7th Earl (1590–1616), under whose lordship new and more detailed ordinances were drawn up in 1590. The first marks known to have been recorded were in 1554 and by 1568 around sixty marks had been registered.

This organisational framework nurtured an industry, which was based firmly on the exploitation of the local resources of coal measure ironstone from which the earliest metal articles were made, and easily reached shallow coal seams and charcoal (from the large number of managed woods throughout the manor) for smelting and smithing fuel. Grindstones from the coal measure sandstone quarries were also available for putting the cutting edge on the finished articles. And, most importantly, many water-powered sites could be created on the Don and its fast-flowing tributaries to power the forge hammers and grinding wheels.

In the will of 1510 of Thomas Parker, scythe maker, who had moved from Norton which was the main centre of scythe making in the district, to the Whitley valley in Ecclesfield parish, he left to his younger son the 'takke' [tenancy] of his 'watterwheles', a 'fourness' [furnace], 'ij stythies' [two anvils], his 'smithy gear', 'ij stoones' [two grindstones] and 'troughs called coltroughes' [stone troughs which were filled with water and in which a smith plunged red hot blades to cool them during the hardening process]. To his elder son, besides bequeathing him the copyhold of his land, Thomas left at the wheel in the Whitley valley two coltroughs, an anvil and a pair of bellows.

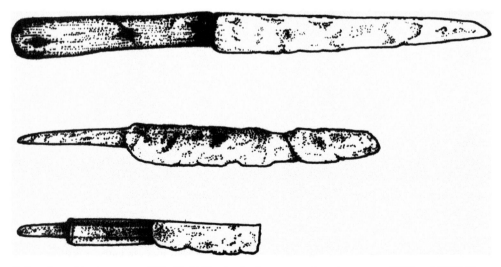

Knives found in the moat of Sheffield Castle during excavations between 1927 and 1929. They date from the fifteenth to the seventeenth century.

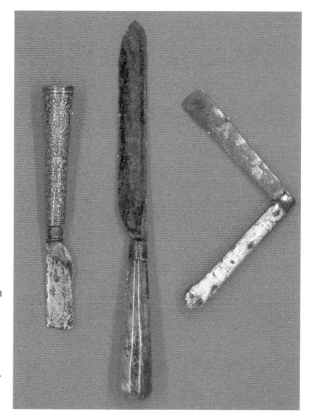

Right: Early knives carrying Sheffield makers' marks, left to right: William Creswicke, 1632; James Mycock, c. 1680; and William Marsh, 1693–1710. (Courtesy of the Millennium Galleries)

Below: The tomb of the 6th Earl of Shrewsbury in Sheffield Cathedral. He was a supporter of local industry.

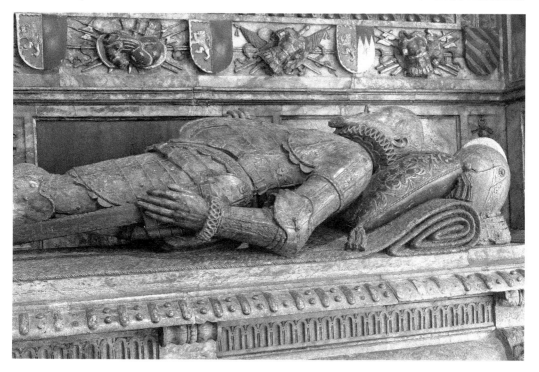

An early bell pit exploiting a shallow coal seam.

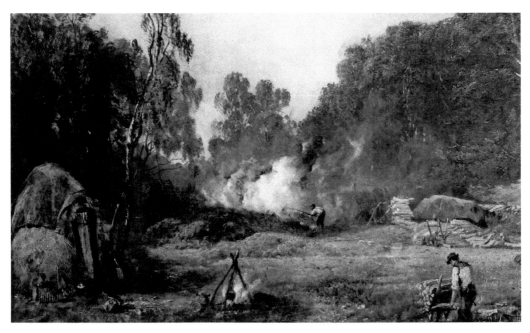

Charcoal making (detail from a painting by John William Buxton Knight).

Grindstones.

Whitley Hall, now a hotel, as portrayed in a painting by Juliana Ewing in the 1870s. The hall stands on the site of an early fifteenth-century scythe works.

THE SEVENTEENTH AND EIGHTEENTH CENTURIES: INVENTION AND CHANGE

Organisational change of the light steel trades followed the death of the 7th Earl of Shrewsbury in 1616. The Sheffield estate descended to Thomas Howard, Earl of Arundel and Surrey, who had married the 7th Earl's youngest daughter, Alethea. They did not live in Sheffield and the Sheffield cutlers lost the personal interest of the new lord of the manor. Two years before his death the 7th Earl had anticipated that changes needed to be made in the affairs of Hallamshire's cutlers and he had given permission for the jury of sixteen cutlers (which had been part of the new ordinances of 1590) to issue marks. This semi-freedom and autonomy made them take another step. They presented a successful bill to Parliament in 1624. The bill – An Act for the Good Order and Government of the Makers of Knives, Sickles, Shears, Scissors and other Cutlery Wares, in Hallamshire, in the County of York, and the parts near adjoining – was passed by the House of Commons in April and the House of Lords in May. Thus the Company of Cutlers in Hallamshire came into being. At the time of the passing of the Act there were 498 master craftsmen (440 knife makers, thirty-one shear and sickle makers and twenty-seven scissors makers). Later in the century other specialist craftsmen were admitted and in 1682 there were over 2,000 master craftsmen who had become members of the 'communality', including scythe makers, file smiths and awl blade makers.

By the mid-seventeenth century some 60 per cent of workers in Sheffield worked in the cutlery trades. Many of these workmen were 'little mesters' who ran their own businesses with the help of apprentices from small workshops attached to their cottages. Here might be a coal-fuelled smithy where blades were forged or small rooms where the handles were fitted or 'hafted' and where knives were finally assembled after the blades had been taken to a riverside cutlers' wheel to be ground on a grindstone. Some cutlers might specialise in forging, grinding or assembling. The lists of personal possessions left in wills of the cutlers and those in related trades from Hallamshire and the surrounding district from the sixteenth and seventeenth centuries show clearly the nature and scale of the work undertaken; for example, in 1694 cutler Charles Stewardson died and the inventory of the tools in his two-storey workshop listed seven vices, a 'glaser' (a leather-covered wooden wheel dressed with emery cake for finishing blades), six pairs of boring stoops, wire and a parcel of tortoiseshell for knife hafts; and in 1718 John Winter's smithy tools included an anvil, a pair of bellows and 30 pounds of shell for use in hafting.

The existence of fast-flowing streams from the Pennines, which could be exploited many times at short intervals during their course through the district, gave Sheffield and surrounding

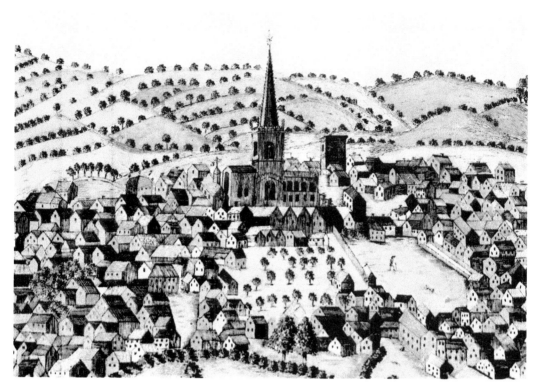

Above: Thomas Oughtibridge's view of Sheffield in 1737 when it was a bustling centre of local industry.

Right: The first Cutlers' Hall.

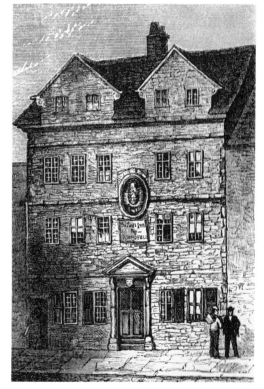

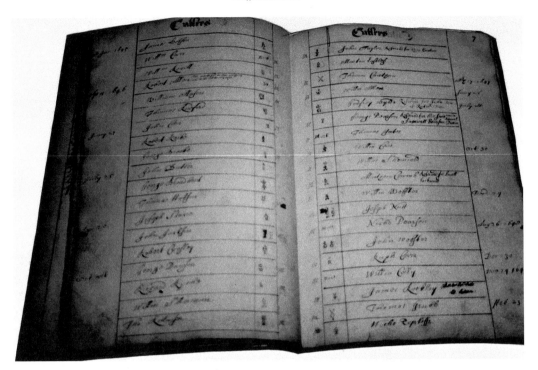

The Great Mark Book of the Company of Cutlers, which runs from 1678 to 1791.

Tho: Lebbon .	⚓ P
Riche:: Shaw .	⚓ ⚓
William Fuhr .	⚓
Antho: Beete .	◇
Theo: Hobbon the young^r .	⚓ ◇
Ribbe Morekham .	⚓
Fuhy: Newbourne	⚓

Detail from the Great Mark Book. (Courtesy of the Company of Cutlers in Hallamshire)

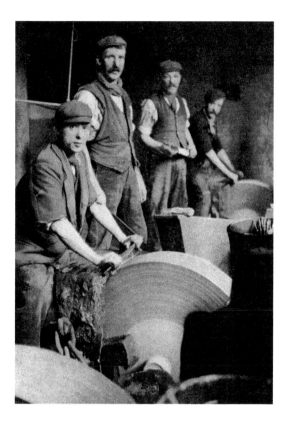

Grinders at work.

parishes a critical advantage over their provincial rivals during the seventeenth century and over London and their foreign rivals by the end of the eighteenth century. By 1637, for example, when John Harrison undertook his survey of the manor of Sheffield he was able to report in his general description of the manor on the significance of the 'River of Doune', 'ye Sheaf' and the other Sheffield rivers, which he called 'Porter Water, Loxley Water & Riveling Water with other small Rivers & Brookes'. These rivers, he said, '… are very profitable unto ye Lord in regard of the Mills [i.e., water-powered corn mills] & Cutler wheeles that are turned by theire streames, which weeles are imployed for the grinding of knives by four or five hindred Master Workmen that gives severall marks'.

In the survey itself he listed rents from thirty-one 'Cutler Wheeles'. It has been estimated that there were around fifty water-powered industrial sites on Sheffield's rivers by 1660, that this had risen to around ninety by 1740 and to around 130 by the end of the eighteenth century, after which only a handful of new sites were created. At the height of the use of waterpower on Sheffield's rivers waterwheels occurred on average four times on every mile of river.

The usual method of harnessing waterpower on Sheffield's rivers was to build a weir to deflect water from the river into a reservoir, locally called a dam, via a channel called a head 'goit' or 'leat'. The dam was generally parallel to the river but at a higher level. Water was led from the dam onto a vertical waterwheel and then flowed away, via a tail goit, to rejoin the river downstream. When the fall of water was over around 10 feet an overshot wheel was normal, with the water hitting the wheel close to the top. Where the fall of water was lower, a breast wheel would be used with the water feeding it lower down. Very low falls of water fed undershot wheels. Undershot wheels were rare in the Sheffield area.

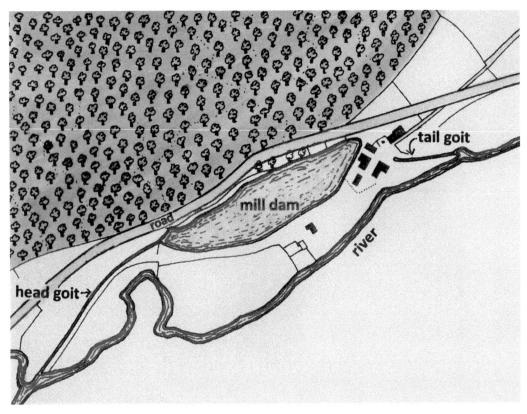

The method of harnessing water power on Sheffield's rivers.

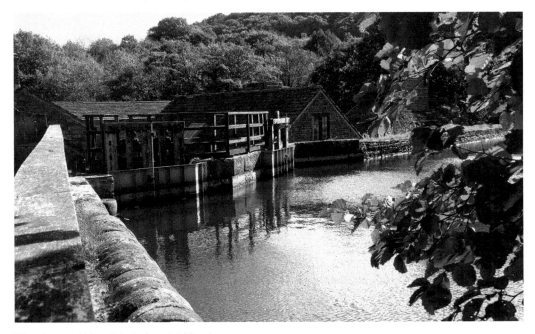

The dam at Abbeydale Industrial Hamlet.

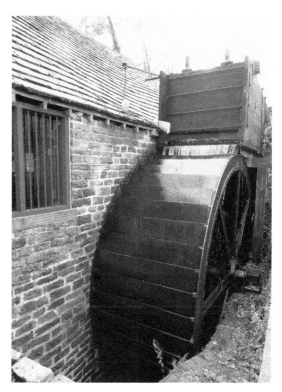

A surviving waterwheel at Shepherd's Wheel.

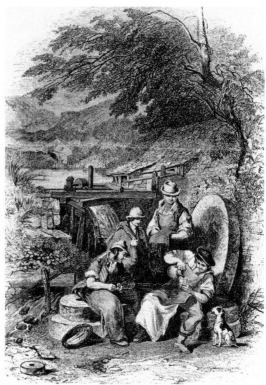

Workers at a waterwheel enjoying a work break.

By the end of the seventeenth century Sheffield knives and edge tools were not only sold throughout Britain and Ireland but had penetrated markets abroad, reaching the mainland of Europe, the West Indies and the North American colonies. And in Europe they were sold well off the beaten track. John Spencer (1655–1729) of Cannon Hall, for example, had merchant interests in the Baltic region. In the late 1680s and early 1690s he is known to have been exporting 'Sheffield wares' including knives, penknives, spring knives and forks, razors, inkpots and buttons from Hull to Narva, a port on the southern shores of the Gulf of Finland.

Until the second half of the eighteenth century the steel used by Sheffield's cutlers was either imported or was locally made 'shear steel', which was forged from 'blister steel' made in a cementation furnace. Some 260 such furnaces were eventually built in the Sheffield area, of which only one survives (on Doncaster Street). In a cementation furnace in two sandstone chests were put alternate layers of charcoal and iron bars covered by a layer of mortar made from 'wheelswarf' – the debris of sand and steel grindings from the bottom of a grinder's trough. The furnace was sealed and a coal fire lit below the sandstone chests, which burned for seven to nine days. After around a week of cooling down, the furnace was opened and the iron bars now converted to blister steel (they were covered in small blisters) were removed. The bars of blister steel were then converted into shear steel by being heated in bundles to bright red and then forged into a uniform bar. Shear steel could be ground to produce a sharp cutting edge but was still not completely uniform in carbon content and was not suitable for all steel products.

This led to the development of crucible steel by Benjamin Huntsman in the 1740s. Born to Quaker parents in Epworth, Lincolnshire, in 1705, Huntsman became a clockmaker in Doncaster in 1725. He was dissatisfied with the quality of steel available to him for making

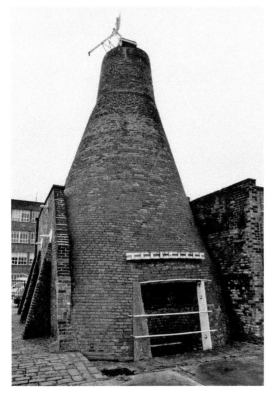

The only surviving cementation furnace in Britain on Doncaster Street, Sheffield.

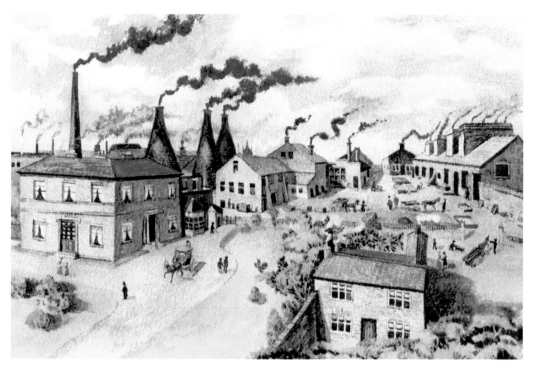

Huntsman's works in Attercliffe with the tall cone-shaped cementation furnaces on the left and the rectangular-shaped crucible furnaces on the right. (Courtesy of June Limb)

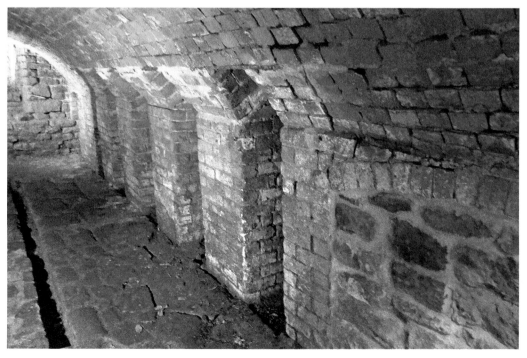

The lower level of a set of crucible furnaces. (Courtesy of Helen Jackson)

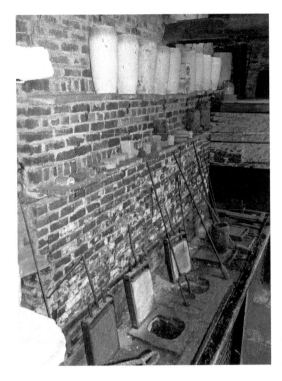

The upper level of a set of crucible furnaces at Abbeydale Industrial Hamlet.

clock springs, so he experimented in producing a homogeneous steel without variations in carbon content. He moved to Handsworth and conducted experiments, which involved devising a way of remelting blister steel to create an almost 'pure' steel of consistent quality for clock spring making. To do this he put broken bars of blister steel in small clay pots (crucibles) in a coke fire at very high temperatures (1,550–1,650 degrees Fahrenheit) for up to five hours. What he in fact produced was the ideal steel for cutlery and edge tool making. By 1751 he had moved to Attercliffe to take up the full-time occupation of steelmaker. Although the introduction of crucible steel was at first resisted by Sheffield's cutlers (who said it was hard to work), eventually it resulted not only in the worldwide renown of the Sheffield cutlery industry, but also in the growing international reputation of Sheffield as a steel-making centre. By around 1850, 90 per cent of the country's steel (crucible steel) was made in Sheffield and nearly 50 per cent of all the steel made in Europe was Sheffield made.

The process of making crucible steel has taken on an almost mythical quality, celebrated in drawings, engravings, paintings and sculptures (at Meadowhall shopping centre). After some three hours in the underground furnace, the 'puller-out', wearing protective leggings, a sacking apron and a glove on the hand used to hold the tongs nearest the 'fire hole', inserted his long tongs and skilfully removed the glowing crucible from the mass of brightly burning coke, placed it on the floor and removed the lid. The head melter or 'teemer', like the puller-out protected by leggings, apron and gloved hand, then lifted the crucible with tongs, using his thigh as a fulcrum, and poured the red-hot metal into a waiting ingot mould that was 30 inches high and only 3 inches by 3 inches wide. The skill and strength involved to handle the intense heat (the combined weight of crucible, steel and tongs being around 100 pounds) was immense. One contemporary observer said the process was very beautiful when performed at night.

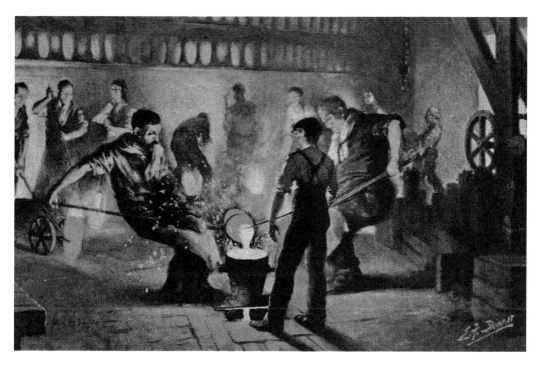

Above: Pouring crucible steel.

Right: Thomas Boulsover, inventor of Old Sheffield Plate.

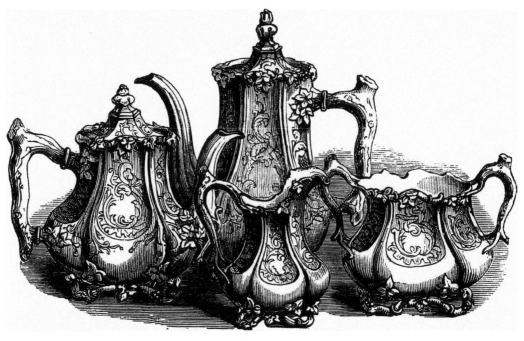

Old Sheffield Plate. A tea set by Broadhead & Atkin.

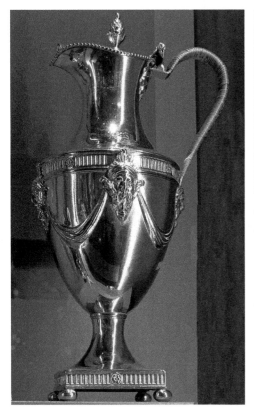

Above: Britannia Metal teapot by
John Harrison. (Courtesy of the
Millennium Galleries)

Left: Old Sheffield Plate. A hot-water jug by
Richard Morton & Co., 1773. (Courtesy of
the Millennium Galleries)

Also, during this period, another development that would have an immense impact on Sheffield's light industries was taking place in Norfolk Street in Sheffield. Thomas Boulsover (1704–88), a cutler, was repairing a knife whose handle was made of silver and copper when he realised that a thin sheet of silver could be fused together with copper to give the impression of solid silver. Boulsover had to roll and craft his plated silver, which became known as Old Sheffield Plate, by hand, but soon other firms were entering the trade and during the second half of the eighteenth century firms such as John Hoyland & Co., Joseph Hancock, and Tudor, Leader and Sherburn became major manufacturers of a wide range of plated silver articles including snuffboxes, pocket flasks, buckles, buttons, candlesticks, and a wide range of fancy 'hollow ware' such as coffee pots, jugs, dishes, bowls and trays.

White metal, or Britannia metal as it became more widely known, composed of tin, brass, copper and a small amount of antimony was invented around 1769 by James Vickers and this new alloy took over the lower end of the market as a substitute for pewter. Because the manufacture of articles in silver plate, Britannia metal and then solid silver involved substantial capital investment; these branches of the light trades were among the first to fully embrace the idea of an integrated factory-based operation with specialist craftsmen recruited from all parts of the country. So important had the manufacture of articles in solid silver become by the 1770s that Sheffield was granted permission in 1773 to open an assay office.

And for a short period of just over a century from 1650 to 1758, at Bate Green between Bolsterstone and Stocksbridge, in what is now the extreme north-west of the modern metropolitan borough, there existed a small glassworks, the Bolsterstone Glassworks. It gained a high reputation for its glass objects, and these found their way into the homes of the refined middle classes and even reached the London market.

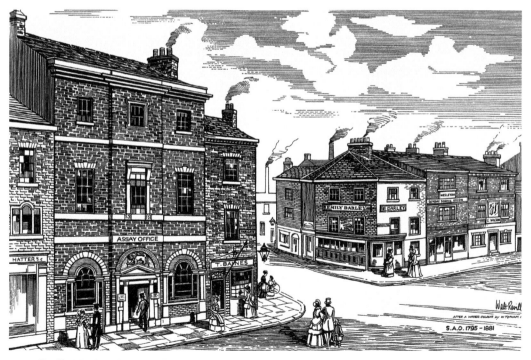

Sheffield's first Assay Office (left) on Norfolk Street. (Courtesy of Sheffield Assay Office)

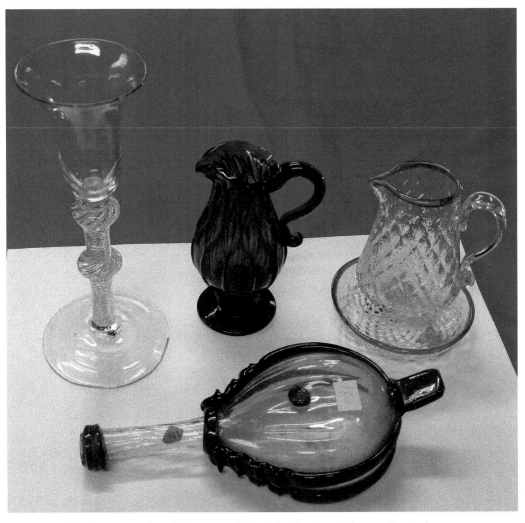

Examples of Bolsterstone glass. (Courtesy of Stocksbridge Local History Society)

THE AGE OF STEAM AND INDUSTRIAL EXPANSION

The last major innovation of the eighteenth century came in 1786 when steam power was applied to the grinding process. This had a number of important consequences. First it led to the gradual abandonment of many water-powered sites, one estimate suggesting that the number of water-powered sites shrank from more than 130 in 1770 to around thirty a hundred years later. The new steam-powered workshops were overwhelmingly concentrated in the town of Sheffield itself, mainly around the western edges of the built-up area, and they later colonised the valley slopes above the River Sheaf to the south of the existing town, an area laid out on a grid-iron plan by the principal landowner and lord of the manor, the Duke of Norfolk, between 1771 and 1778. The concentration of an increasing volume of the industry's capacity in an urban setting enabled the workmen to work at their trades full time throughout the year, unworried by possible loss of power during the hot and dry summer months and uninterrupted by farming activities. But craft techniques did not change in the traditional branches of the industry, with the result that the industry remained, to a large extent, in small units.

The nineteenth century saw much expansion in the number of manufacturers and workers as markets grew and grew, and the range of products multiplied. For the first three quarters of the century Sheffield was the steel and steel products capital of the world. The period also saw the declining influence of the Cutlers' Company; the invention of electroplating to supersede Old Sheffield Plate; the introduction of artificial hafting materials such as celluloid (introduced in 1868), ebonite, vulcanite and xylonite; and the slow substitution of the integrated factory and mechanised operations in place of the small smithy and workshop and traditional hand crafts.

Market expansion not only took place domestically, but also internationally, especially in the Empire and the United States, and to a lesser extent in Europe and South America. Transport developments were crucial. In the seventeenth and eighteenth centuries, the products of the Sheffield light trades industry were moved to their markets by packhorse with as many as fifty at a time leaving the town for the ports of Yorkshire and Lancashire. The inconvenience and slowness of overland journeys led the Cutlers' Company to explore the possibility of making the Don navigable from Doncaster to Sheffield and in 1726 work began. But it proved impracticable at the time to extend the waterway beyond Tinsley and so Tinsley remained the

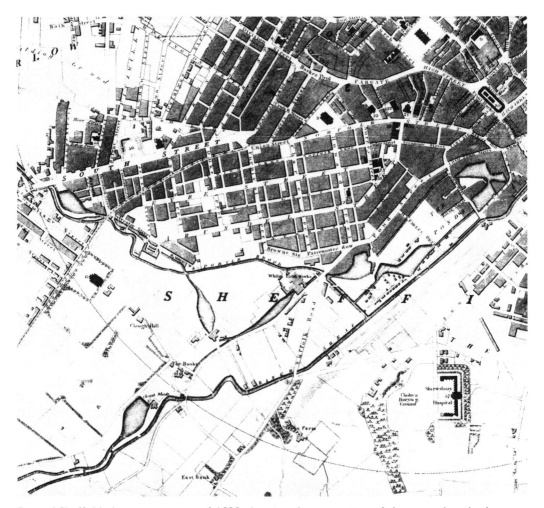

Part of Sheffield shown on a map of 1832 showing the expansion of the town, largely the result of the use of steam power in the grinding process.

terminus from 1751 until the late date of 1819 when the Sheffield Canal opened, terminating at the canal basin near the junction of the Sheaf and Don. The first railway to reach Sheffield came only nineteen years later, but it was only a branch line, the Sheffield & Rotherham Railway, which connected the town at Rotherham to the Midland Railway's main line from York to London via Derby. This was followed by the trans-Pennine route of the Manchester, Sheffield & Lincolnshire Railway, which terminated in Sheffield in 1845, the line being extended to Grimsby in 1847. Sheffield then had to wait until 1870 before getting its direct railway route to London, which terminated at the then Midland station.

The biggest foreign market, which had emerged in the eighteenth century even before the North American colonies gained their independence, was in the United States. The population of the United States was only three million in 1786 but as migrants poured into the new country in the nineteenth century, and spread westwards, it had risen to thirty-one million by 1860, and with its own manufacturing industry still in its infancy, the demand for Sheffield

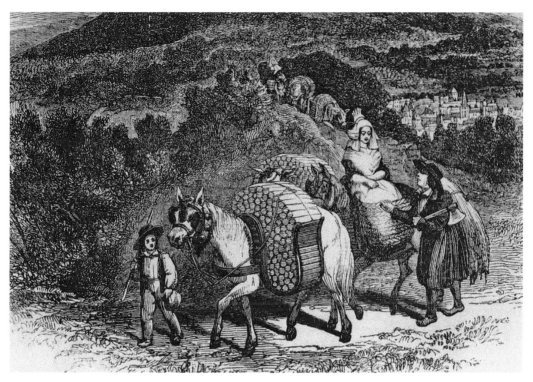

Packhorse transport, the centuries-old way of getting Sheffield wares to their markets.

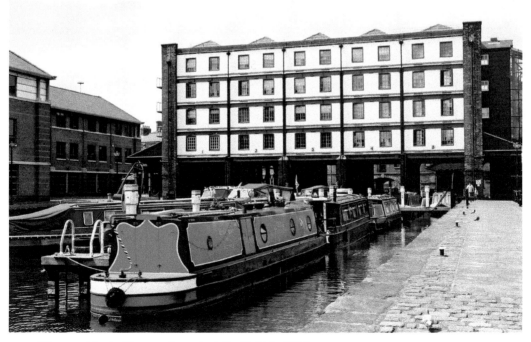

The canal basin. The canal reached Sheffield in 1819.

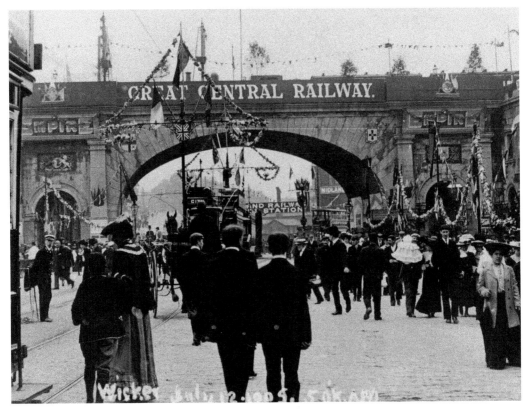

The Wicker Arches that carried the TransPennine railway into Sheffield in 1845 and on to Grimsby in 1847.

steel and steel products must have seemed never-ending. Fortunes were made based on the American trade by firms such as W. & S. Butcher, James Dixon & Sons, William Greaves, Mappin Brothers, Marsh Brothers, Joseph Rodgers & Sons, and George Wostenholm & Son. Some firms even went as far as naming their new works after the American trade; for example, George Wostenholm's Washington cutlery works, Brookes & Crookes' Atlantic cutlery works and Alfred Beckett's Brooklyn saw works.

But as markets rapidly expanded, technology and industrial organisation virtually stood still. At the end of the eighteenth century the concept of the factory was foreign to Sheffield's staple industries and the 'little mesters' smithy' or workshop was the typical unit of manufacture in most branches. In the few factories that did exist in the first half of the nineteenth century it was not uncommon for a skilled artisan to take in work from outside, while it was usual for some men to pay a weekly rent and work completely independently. Many of the well-known firms depended more on the fame of their trademarks than on vast numbers of workmen in one all-purpose factory.

The first integrated factory was the Sheaf Works near the canal basin built in 1823 for William Greaves, manufacturer of steel, razors and cutlery mainly for the American market, and later taken over by Thomas Turton & Sons, who manufactured saws, files, edge tools and railway springs. This was followed by the Globe Works built for the Ibbotson Brothers between 1825 and 1830. By 1850 integrated factories were also operated by two of Sheffield's most famous cutlery

James Dixon's former Cornish works, now apartments.

Fish knife and fork by Mappin Brothers displayed at the Great Exhibition in 1851.

manufacturers – Joseph Rodgers & Son, at the Norfolk Works, and George Wostenholm & Son at the Washington Works – and by one of the two leading plate manufacturers: James Dixon & Sons, at Cornish Place. By the 1860s Wostenholm's Washington Works employed 800 people and in the 1880s James Dixon's plate works had 700 employees. Henry Hoole, a manufacturer of stove grates, fireplaces and Fenders, built the Green Lane Works in 1860. Its decorative façade still greets the observer today. As the century advanced, and some processes became mechanised, more and more factories, small, medium and large, were built. But machine-made articles were considered to be inferior by many manufacturers and craftsmen, and mechanisation took place much more slowly in the Sheffield area than in the United States and Germany.

Above left: The Norfolk Knife. (Courtesy of the Company of Cutlers in Hallamshire)

Above right: George Wostenholm (1800–76).

George Wostenholm's Washington Works.

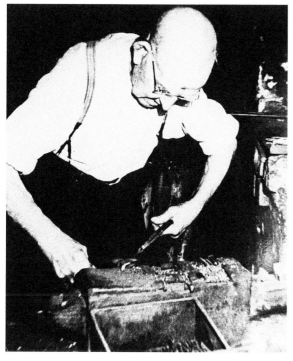

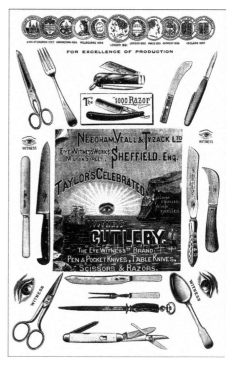

Above left: John Thomas Ridge in his little mester's smithy.

Above right: Eyewitness Works advertisement.

Samples of Sheffield trademarks.

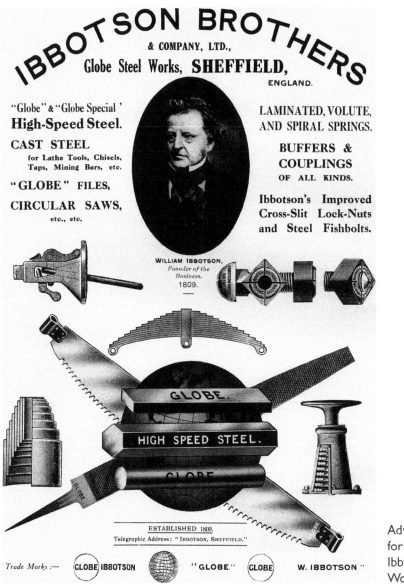

Advertisement for William Ibbotson's Globe Works.

In 1911, there were approximately 35,000 persons employed in the light steel trades in Sheffield, an increase of 39 per cent on 1851 but of only 8 per cent on 1891. This slow recent growth was not indicative of a decline in the industry, which had in fact continued to grow steadily (if unevenly) in spite of the virtual loss of the United States market. It was a reflection of the increasing mechanisation of the industry. By the beginning of the twentieth century electric motors were becoming common in the industry, and the forging of file blades, the cutting of files, the filing of forks and the grinding of saws had all been mechanised. In the electroplating industry the rolling and stamping of products were also done by machine. There were still, however, large numbers of handworkers in the light trades, particularly for the production of luxury articles.

The Globe Works.

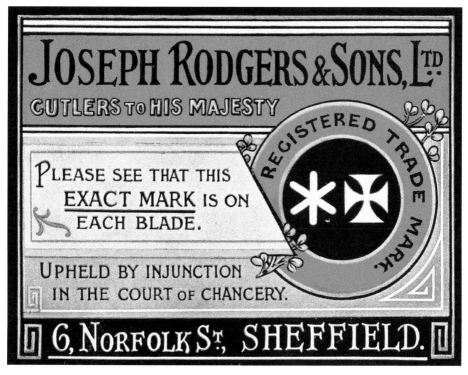

An advertisement for Joseph Rodgers & Sons Ltd.

Hoole & Robson fireplace exhibited at the Great Exhibition in 1851.

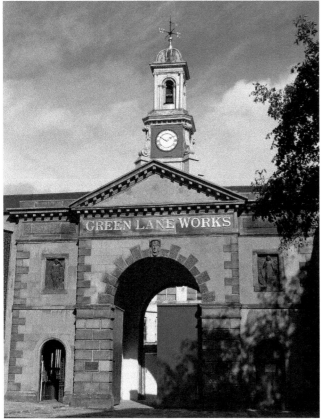

The Green Lane Works entrance today.

Making machine-cut files.

File-making factories in Sheffield continued to employ out-workers making hand-cut files, and out-workers in the surrounding rural area continued in the ancient tradition of combining their trade with a rural occupation. But inevitably employment in file-making in the Sheffield area declined from 6,200 in 1891 to 4,850 in 1911. Contraction in employment in the same period was typical of most branches of the light trades, the exception being the silver and silver plate trades where there had been no change in the methods of production in the second half of the nineteenth century, employment climbing from 5,500 in 1851 to 10,600 in 1911.

The extent to which the very small firm and the out-work system was still typical of the industry may be seen from the Factory Returns of 1904. These reveal that the 15,970 cutlery workers over eighteen years of age in the United Kingdom in that year, most of whom worked in Sheffield, worked in 2,752 establishments – an average of five males and one female per establishment. In contrast to this, at the other end of the scale in the 1890s Joseph Rodgers & Sons employed 2,000 workers, and four other firms – George Wostenholm, James Dixon, Walker & Hall and Mappin & Webb – employed nearly 1,000 each.

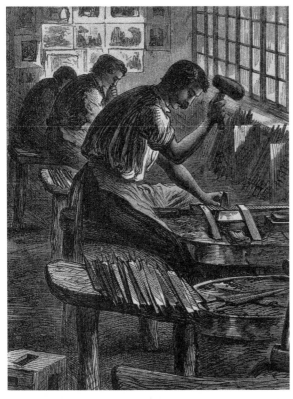

Left: Hand-cut file-making.

Below: The workforce at Henry Greaves' hand-cut file works in Ecclesfield.

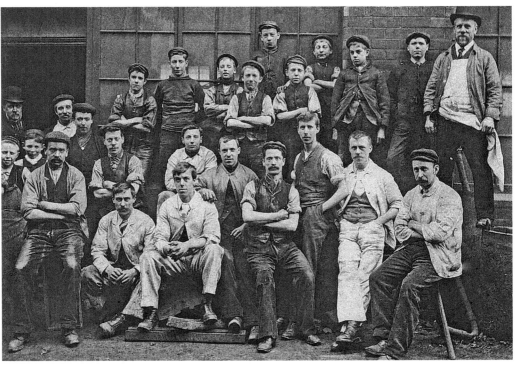

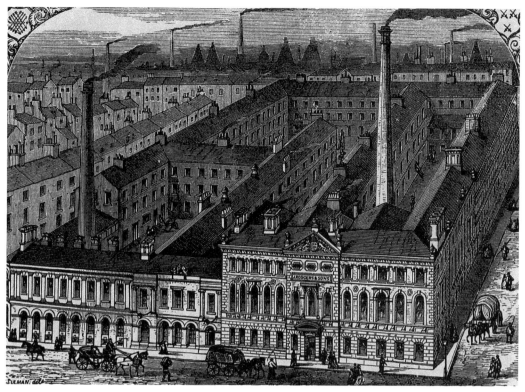

Joseph Rodgers' Norfolk Works.

Although at the very end of the nineteenth century there were still substantial numbers of light steel trades workmen in small- and medium-sized firms in the rural and semi-rural areas surrounding Sheffield, the industry by this time was largely urbanised in Sheffield. However, one industrialist, Samuel Fox, set up his works 9 miles north-west from the centre of Sheffield in the Little Don Valley at Stocksbridge in the 1840s and made his first million from his manufacture of steel wire that his firm used to make umbrellas and the crinoline frames for the dresses of middle- and upper-class Victorian ladies. And 5 miles north of the city centre, at Thorncliffe near Chapeltown, the iron manufacturing firm of Newton Chambers, established in 1793, had an international reputation for manufacturing gas lighting equipment from gasworks to gasholders and gas lamps. Their order books include orders not only from nearby towns like Halifax, Huddersfield and Lincoln, but also from Continental cities including Gothenburg, Hamburg and Rotterdam. And in 1883 they won an order for a complete gasworks plant to light the streets of Buenos Aires in Argentina!

Neither was industrial expansion restricted to the iron and steel industry. More than 100 woods around the town were carefully managed from at least the end of the fifteenth century to the end of the nineteenth century as coppice woods (coppice-with-standards) for the production of charcoal (still used in the production of cementation steel) and tanbark. There were six tanneries in eighteenth- and nineteenth-century Sheffield together with numerous woodland craftsmen such as basket-makers, coopers, and clog-sole makers. There was also a silk mill, a cotton mill, paper mills and even a works manufacturing hackle pins for the textile industry, knitting needles, hair pins, meat skewers and bicycle spokes.

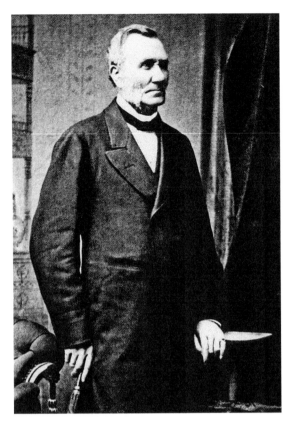

Left: Samuel Fox.

Below: Umbrella makers at Samuel Fox's Stocksbridge Works. (Courtesy of Stocksbridge Local History Society)

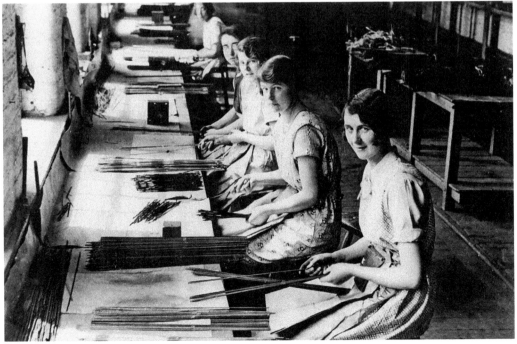

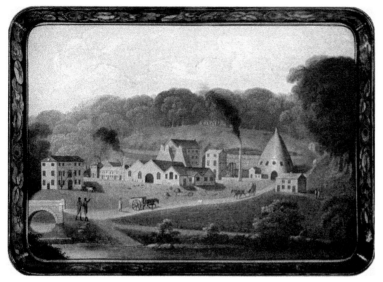

Above: Newton Chambers Ironworks at Thorncliffe *c.* 1800.
The two blast furnaces can be seen in the middle of the picture.

Right: A gas lamp produced by Newton Chambers.

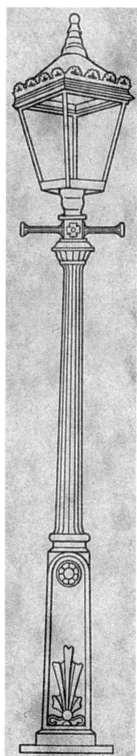

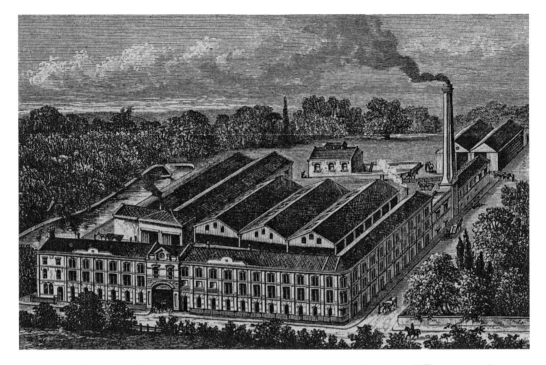

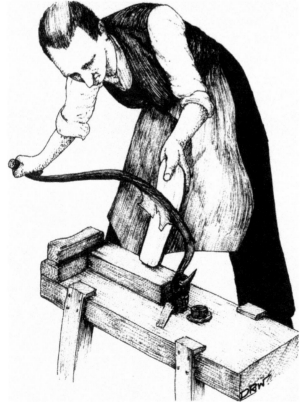

Above: Meersbrook Tannery in the late nineteenth century.

Left: Hand clog-sole making.

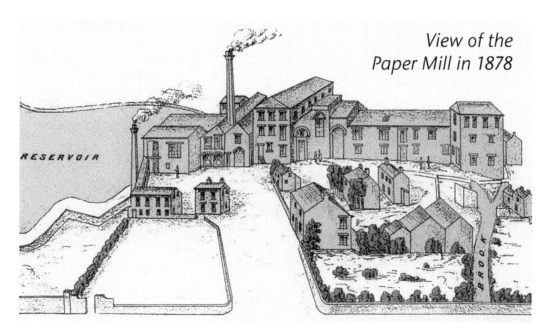

View of the Paper Mill in 1878

RESERVOIR

BROOK

Above: Ecclesfield Paper Mill.

Right: An advertisement for the products of Ecclesfield Paper Mill.

The ATLAS PAPER MILLS CO.,

MAKERS OF

CAPS, BROWNS, GLAZED BROWNS, AND GROCERS' PAPERS;

AND PAPER BAG MANUFACTURERS, BY HAND.

Mills :—ECCLESFIELD, NEAR SHEFFIELD.

Town Office and Warehouse:—37 and 39, UNION STREET, SHEFFIELD.

Medal won at a trade exhibition in Paris by the Hallam Brothers Wire and Pin Works of Ecclesfield.

THE RISE OF THE HEAVY STEEL INDUSTRY AND THE EXPANDING RETAIL SECTOR

The heavy steel and engineering industry was a relative newcomer to Sheffield. It did not emerge on any appreciable scale until the 1850s, but by the end of the nineteenth century had overtaken the light steel trades and had resulted in the vast physical expansion of the urban area and explosive population growth.

The new industry was based on the insatiable market that had arisen for machine parts, axles, tyres, boilers and springs for the railways, steel for guns and shells, and plates for ships. To meet the rapidly growing demand, light steel firms – including what were to become household names later in the century, e.g. John Brown (who started as a cutler), Charles Cammell (file-maker) and Thomas Firth (file, saw and edge toolmaker) – set up new works to manufacture steel on a bigger scale.

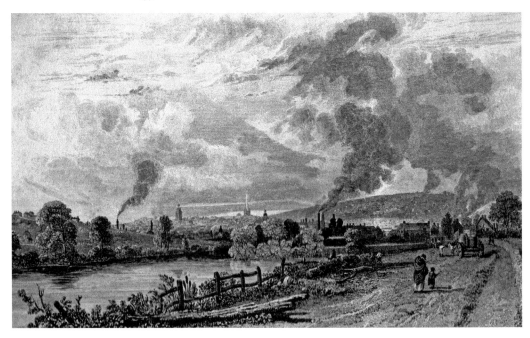

The Lower Don Valley before industrialisation.

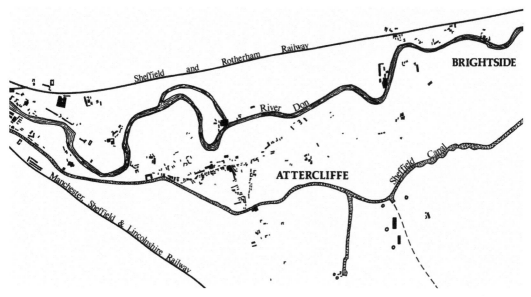

Map of the Lower Don Valley in the early 1850s...

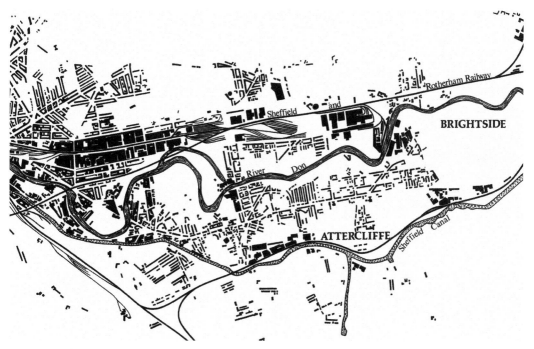

...and in the 1890s.

Throughout the 1850s, before the adoption of the Bessemer process, the only way of producing the large ingots of high-quality steel required by the market was to assemble in one work large number of converting (cementation) furnaces, crucible holes, and puddling furnaces (for making wrought iron for plate production and puddled steel). This naturally led

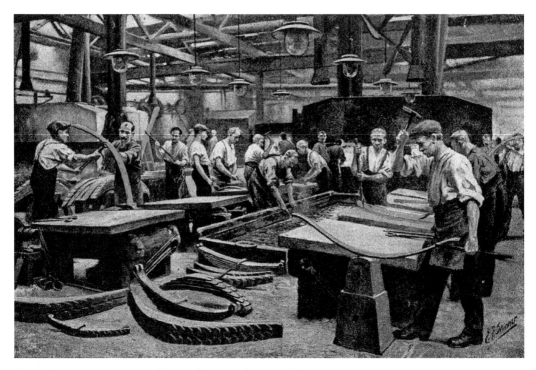

Fitting laminated springs at Cammell Laird's Cyclops Works.

to the growth of large new steelworks. These were mostly built on 'greenfield' sites in the wide Don Valley to the east of the town in Brightside and then Attercliffe. There was flat land beside the river for the construction and subsequent expansion of the large works and in the surrounding area for houses for the workers, who were attracted in large numbers. In addition, there was a constant supply of water from the River Don and access via the Sheffield & Rotherham Railway and its branch lines to the coking coal from local collieries, and to the pig iron from the Continent. The new industry also took advantage of good locations beside the Manchester–Sheffield Railway to the north-west of Sheffield in the villages of Owlerton, Wadsley, and Oughtibridge, and even Stocksbridge on the Little Don where Samuel Fox had set up his works in 1841 (see chapter 'The Age of Steam and Industrial Expansion'). It has been calculated that the light and heavy steel trades of the Don Valley between Stocksbridge in the north-west, round the elbow bend and through Sheffield, past Rotherham to Swinton, accounted for 80–90 per cent of British steel-making capacity in the early 1850s.

The Bessemer converter made its first appearance on Carlisle Street at Bessemer's Steel Works in 1858, in the very midst of the new steelworks with their many cementation furnaces and crucible holes. This was a radical step by its inventor Henry Bessemer following the sceptical reception of the new invention that arose from doubts about the process itself and about the quality of the large amounts of steel that were produced in such a short space of time. Traditional methods of converting pig iron into blister steel and then into crucible steel took fourteen or fifteen days to produce a 40–50 pound ingot of cast steel, whereas the Bessemer process could produce 6 tons of cast steel in around thirty minutes. Two of Sheffield's major new firms, John Brown's and Charles Cammell's, became the earliest converts and produced their first Bessemer steel rails in 1861, followed by Samuel Fox in 1863.

Right: Sir John Brown.

Below: The manufacture of crucible steel at Cammell Laird's Cyclops Works.

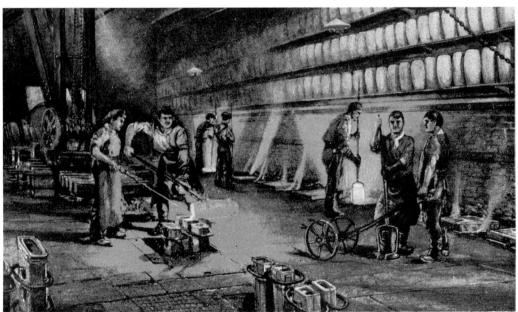

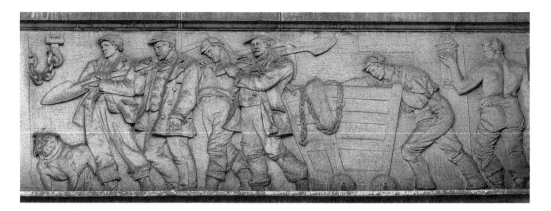

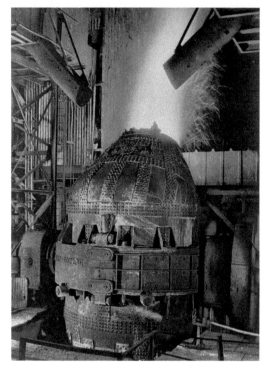

Above: Frieze on the wall of Sheffield Town Hall showing coal miners at work.

Left: A Bessemer converter.

By the first decade of the twentieth century there were at least eight heavy steel firms each employing more than 2,000 workers and six firms employing between 1,000 and 2,000 men. The biggest concentration of the heavy steel and engineering industry was in Brightside and Attercliffe – the 'East End' of Sheffield. The beginnings of this massing together of the new industry had been evident in the 1850s, but by the beginning of the twentieth century it was no longer a thin and broken line of industrial premises but an almost solid mass of works and railway sidings surrounded by rows of terraced houses. The greatest concentration of works began within half a mile of the city centre along Carlisle Street and Savile Street. This complex included Charles Cammell's Cyclops Works, John Brown's Atlas Works (both works appropriately named after giants of Greek mythology), Henry Bessemer's Steel Works and Thomas Firth's Norfolk Works, with the railway running beside and between the works.

Interior of the Bessemer Steel Works.

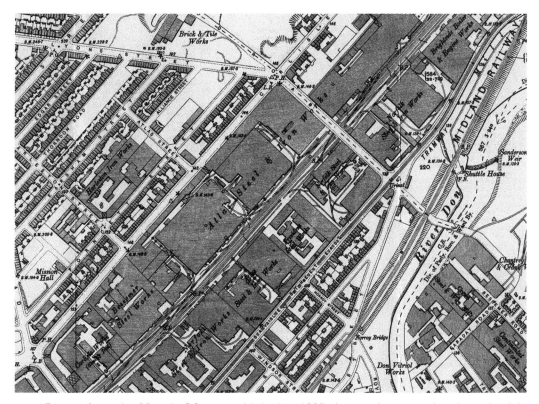

Extract from the 25-inch OS map published in 1905 showing heavy steelworks and tightly packed housing in the Lower Don Valley.

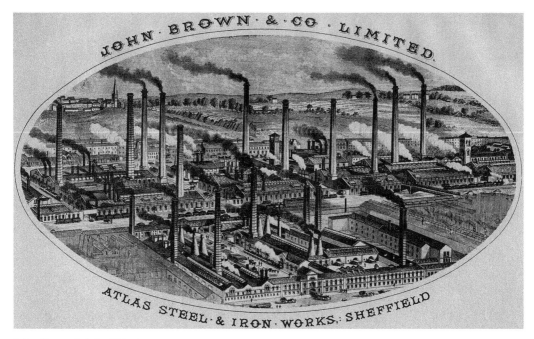

John Brown's Atlas Works.

Group of moulders at Newton Chambers' Thorncliffe Ironworks.

The new steelworks attracted to the east end of Sheffield a rapidly growing population. Brightside's population trebled between 1841 and 1861 (from 10,089 to 29,818), doubled by 1881 (to 56,719) and had reached 75,000 by the end of the century. Attercliffe's population growth was not quite on the same scale but still impressive: from 4,156 in 1841 to 7,464 in 1861 then a giant leap to nearly 30,000 in 1881 and to nearly 52,000 in 1901. And a great number of the new residents of Brightside and Attercliffe, and Burngreave, Grimesthorpe and Darnall, were in-migrants from near and far; for example, a study of the inhabitants aged fourteen years and over living in ninety-four houses in Forncett Street in 1871 within a stone's throw of three important steelworks belonging to Henry Bessemer, John Brown and Charles Cammell showed that 85 per cent (408 out of 449) were migrants.

After the re-equipment of the railways in Britain with steel rails, rail manufacture tended to move to the coasts from where overseas markets could be more easily served. Although the unfavourable locational circumstances checked the production of common-grade steel in Sheffield, they did not check the development of the industry; they merely diverted development into new channels, namely the production of steels where the cost of manufacture and the value of the product far exceeded the cost of raw material assembly and distribution, and in whose making scrap could be extensively used. Specialisation became the keynote of the heavy trades and the research laboratory became an important factor in the Sheffield steel industry after 1880.

The most famous names in the industry increasingly concentrated on armament production, John Brown's and Cammell's increasingly specialising in the manufacture of armour plate, and Firth's on gun barrels and armour-piercing shells. Before the First World War Sheffield was 'the greatest Armoury the world has ever seen'. Other firms also increasingly concentrated production on specialised products. For example, Samuel Osborn's specialised in cast steel 'of every description from a few ounces to 15 Tons each' and were the sole manufacturers of Mushet's 'special steel' and 'titanic steel' used in the manufacture of specialised tools, drills and dies; Jessop's specialised in cast steel for engineering, machinery and edge tool purposes; Jonas & Colver's specialised in steel for small arms manufacture; and W.T. Beesley manufactured

Rolling armour plate.

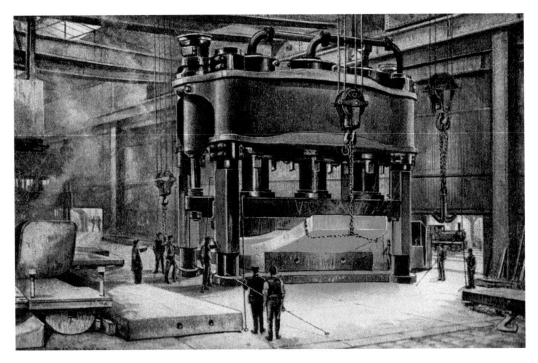

Above: Bending armour plate under a 12,000-ton press at Cammell Laird's.

Left: Advertisement for Samuel Osborn & Co., manufacturers of 'high speed steels'.

The former works of Samuel Osborn & Co. Ltd today.

Advertisement showing Vickers' 'contribution to the British naval fleet up to August 1914'.

steel to a quarter of a thousandth of an inch in exactness. John Brown's, Cammell's and Vickers also had shipyards at the coast and in 1910 it was claimed that all three firms were capable of 'turning out a battleship complete'.

By the beginning of the First World War, in spite of the steady expansion of the light steel trades the heavy steel trades dominated industry in Sheffield. Between 1891 and 1911

employment in steelmaking had increased by 50 per cent and in engineering by more than 80 per cent. There were 193 firms in the city engaged in refining and manufacturing steel, forty-one firms engaged in rolling and forging steel and there were thirty-three foundries.

But as in the first half of the nineteenth century, it was not just the steel industry that expanded. In the early 1840s George Bassett started his liquorice sweets business and by 1862 he employed 150 workers making delicious liquorice comfits, candied peel and Pontefract cakes. Later, of course, the firm 'invented' Liquorice Allsorts. This came about, apparently, when a 'rep' was visiting a customer and an assistant accidentally dropped a tray of samples onto the floor. The customer liked the assortment, and so Liquorice Allsorts came into being. In the 1920s the Bertie Bassett trademark was designed and with minor alterations is still being used. The firm is now part of the Maynards Bassetts group. In 1883 one of the best-known food product firms was established – Henderson's Relish, Sheffield's answer to Worcester Sauce. The firm is still going strong today. And in 1895 William Batchelor founded Batchelor Foods, which for many years occupied a factory at Wadsley Bridge, in the upper part of the Don Valley. The firm became famous for the production of processed peas (including 'mushy peas') and Cup-a-Soup. And for a short period between 1908 and 1925 Sheffield had its own car industry. Simplex cars, owned by Earl Fitzwilliam of Wentworth Woodhouse, produced luxury cars and motorcycles.

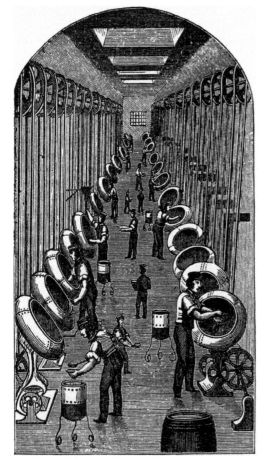

Left: Bassett's comfit room.

Opposite above: Henderson's Relish.

Opposite below: A Simplex car.

Considerable expansion also took place in the retail sector as Sheffield's population grew and grew, and by the end of the nineteenth century the retail core stretched for more than a mile from Haymarket in the north to the bottom of The Moor in the south. By the 1850s Sheffield had a number of markets across town. The Norfolk Market Hall opened in 1851 on Haymarket with money given by the Duke of Norfolk. The hall was 296 feet long and 115 feet wide with stalls and shops around an enormous fountain. On sale were fruits, vegetables and confectionary. There was also the Smithfield Market for cattle, hay and agricultural implements and the Sheaf Market for agricultural and market garden produce together with poultry, rabbits, dogs and birds. The Fitzalan Market Hall sold meat, fish, game, poultry and butter.

By the 1870s Sheffield also had two co-operative societies. Serving the northern part of the town, the Brightside & Carbrook Co-operative Society was established in 1868 and by 1914 had 29,000 members. The Sheffield & Ecclesall Co-operative Society, originating in the Ecclesall Road area in 1874, also expanded quickly and by 1925 had twenty-nine grocery branches.

By that time there were also four department stores in the booming town. The first one was Cockayne's established in 1829 by Thomas Bagshawe Cockayne and his brother William. It started as a draper's store before becoming a large department store on Angel Street by the end of the century. Meanwhile Cole Bros (now John Lewis) was established at No. 4 Fargate (Cole's Corner) in 1847. It was owned by three brothers – John, Thomas and Skelton Cole – who were described as 'silk mercers and hosiers'. They extended the original shop along Fargate and round onto Church Street and began selling a wider range of goods including shawls, bonnets, furnishings, carpets and sewing machines. Cole's Corner, as the area came to be known, was a favourite meeting place and the title of a Richard Hawley album. Atkinson's, which is still going strong as an independent family store, began as a small drapery

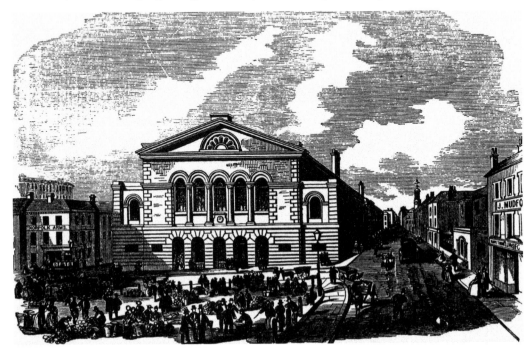

Exterior of the Norfolk Market Hall.

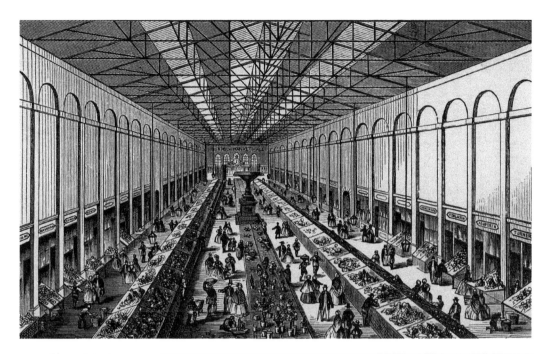

Above: Interior
of the Norfolk
Market Hall.

Right: Cole
Brothers'
department store.

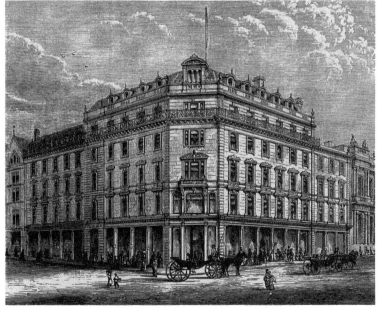

store on The Moor in 1872. John Atkinson, who started the business, specialised in hosiery, ribbons and lace. Over the next thirty years business kept expanding both in floor space and the range of goods on offer and by 1902 the original premises had been demolished and a new purpose-built store erected. John Walsh, who had worked as a shop assistant at Cockayne's, opened his first store in 1875 and in 1899 opened his purpose-built store on High Street that was five storeys high, covered more than 3 acres and employed over 100 members of staff.

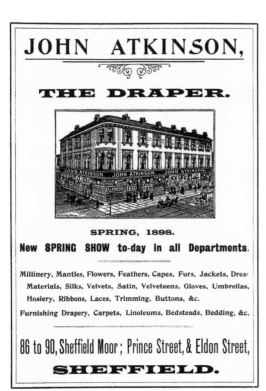

Advertisement for Atkinson's department store.

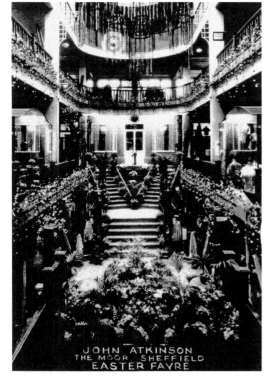

Interior of Atkinson's department store in the 1920s.

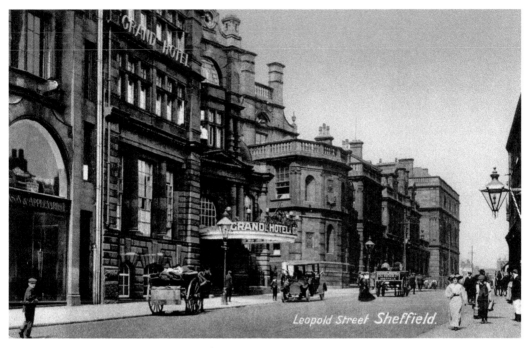

Leopold Street in the early twentieth century.

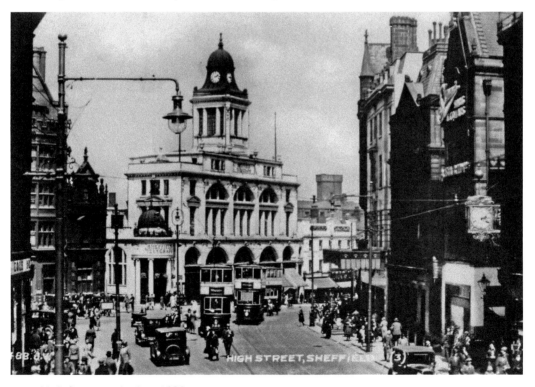

High Street in the late 1930s.

THE WAR YEARS AND BEYOND

A major scientific breakthrough came in 1913 when Harry Brearley, director of Brown-Firth's research laboratories, discovered a chromium steel that almost completely resisted corrosion. This was the famous stainless steel. The first stainless steel knives were produced for sale in late 1914. This groundbreaking discovery changed the face of cutlery manufacture after the First World War. But the discovery coincided with the outbreak of the war, and the government insisted that a more strategic use of stainless steel must prevail – the manufacture of aeroplane engine parts for the flying machines of the Royal Flying Corps. Cutlery manufacturers spent the war years in full production of army knives, bayonets, steel helmets, cutlery and razors for soldiers, sailors and airmen and other military equipment. Tool manufacturers also diverted their production to military markets. The First World War was followed by a short-lived boom in the light trades, which began in 1921 and lasted until rearmament began in the second half of the 1930s. In this period stainless steel became the premier steel for cutlery making, and steel made in electric arc and induction furnaces became the main raw material among the leading toolmakers.

Harry Brearley, inventor of stainless steel.

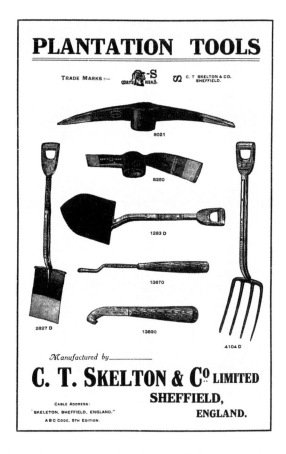

Plantation tools manufactured by
C. T. Skelton & Co. Ltd.

During the First World War production in the heavy steel and engineering industry was also at a very high level, with the Ministry of Munitions coordinating production levels and types of specialisation. The Simplex car company even supplied armoured vehicles for wartime use. For the first time many women worked in the steel industry in the East End. And the industry itself was modernised to meet the wartime needs for armaments and was equipped with modern methods. Output almost doubled that of pre-war days. Following the end of the First World War there was also a short boom in the heavy steel industry. In this period the progressive firms sought and supplied new markets to replace the old ones: China, Japan, Australia, Canada and the British colonies now loomed much larger overseas and the new aircraft and motor car industries provided new outlets for special steels. But the boom did not last and it was over by late 1920.

There was in fact a success story – not for a steel firm, however, but for a long-established ironworks: Newton Chambers' Thorncliffe Works. The first was the disinfectant Izal, produced for the first time in 1890s. It was a by-product of the production of coke for their blast furnaces. Their famous toilet rolls, initially given away to local authorities purchasing large quantities of Izal disinfectant for their new public toilets, was used to advertise the brand. Medicated toilet rolls went on sale to the general public in the 1920s and the firm went on to produce 137 disinfectant products that sold across the world. The same firm also produced 'cast-iron' houses in the 1920s that could be erected in a few days from prefabricated slabs made from cement and blast furnace slag.

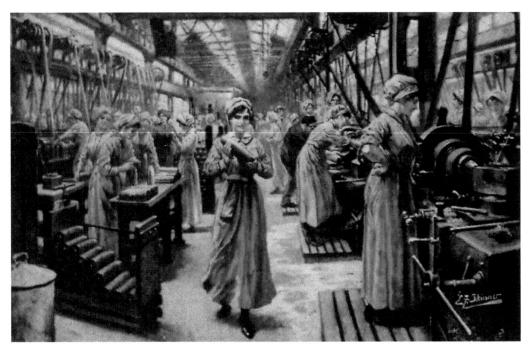

Women employees at Cammell Laird's making shells in the First World War.

Interior of the Izal factory at Chapeltown.

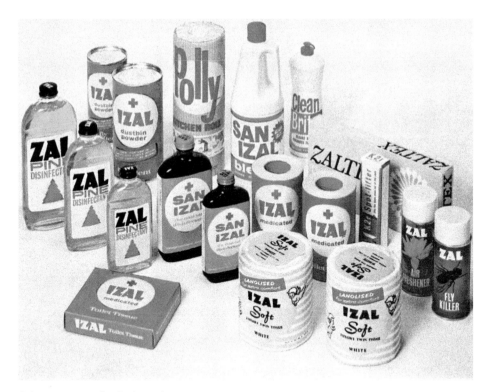

Advertisement for Izal products.

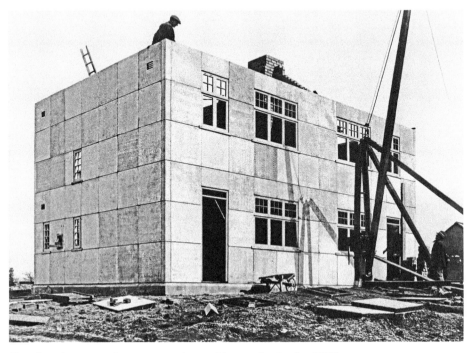

Cast-iron house under construction at Mortomley in the 1920s.

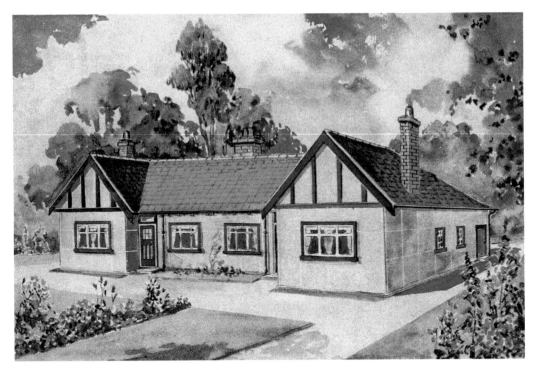

Artist's impression of a cast-iron bungalow.

From the 1920s until rearmament in the second half of the 1930s there was mass unemployment in Sheffield and the heavy steel and engineering industry in particular suffered badly. But technical change went on in this period of recession and depression. The electric arc furnace, which had been introduced just before the outbreak of the First World War, became increasingly important in the production of special steels, output from electric arc furnaces rising from 55,000 tons of ingots and castings in 1920 to 221,000 tons in 1939 – more than three quarters of the total British electric arc production. Electric crucibles also slowly took over from the coke-fired crucible from the late 1920s. Structural reorganisation was also a feature of the heavy steel industry in the interwar period, in the form of amalgamations followed by the much-needed rationalisation.

The six years of the Second World War saw a reversion to the role played by the light trades in the First World War, with cutlery firms fulfilling government contracts for steel helmets, army knives, cutlery for the NAAFI and literally thousands of other types of war equipment including aeroplane parts, gun components, smoke bombs, parachute flares and mine prodders. The tool firms, besides increasing production of such items as spades and shovels, trenching tools, spanners and files, made enormous quantities of forgings and stampings for aircraft, tanks and many other war vehicle components including aircraft undercarriage parts.

After two decades of peace but also mostly of difficult and depressed trading, production in the heavy steel industry again reached full capacity with the onset of war in 1939, and was turned over almost entirely to the production of war materials. For this reason Sheffield became a target for the Luftwaffe. The worst raid came on 12/13 December 1940. Around 300 German aircraft carried out the raid, dropping 350 tons of high explosives and incendiaries. The industrial belt of the East End was the target but the city centre retail area and the

suburbs were the areas most affected. Some of Sheffield's premier department stores were completely destroyed – Walsh's, Cockaynes and Atkinson's. On 15 December another raid took place with ninety aircraft and this time they destroyed the rolling mill of Brown Bayley's.

Despite the withering bomb attacks, the heavy steel works escaped relatively unscathed. And they made a massive contribution to the war effort. At the Vickers' River Don Works, in the first eighteen months of the war, the only drop hammer in the country capable of forging Spitfire crankshafts was produced. The English Steel Corporation's factories also supplied armour plating for the country's fighter planes and tanks and side and deck armour for the Navy's battleships, besides gun barrels of every size and the 'Grand Slam' bomb. A similar story can be told of the work of another great combine, the United Steel Companies Ltd. At their Stocksbridge Works, for example, they specialised in the production of alloy steels, mainly for aircraft production. They also produced springs in large quantities for service vehicles and tanks and for Bren and Bofors guns. The wire products made at the Stocksbridge Works were also in great demand for motor and aero engines and for precision instruments. The umbrella department went over full time to the production of cartridge clips for Browning automatic guns. The war production of Firth Brown was also immense, making more than a million tons of high-quality alloy steel, large amounts of armour for battleships, carriers, cruisers and tanks, and 360,000 bombs and shells. It was said that they could produce 'shells

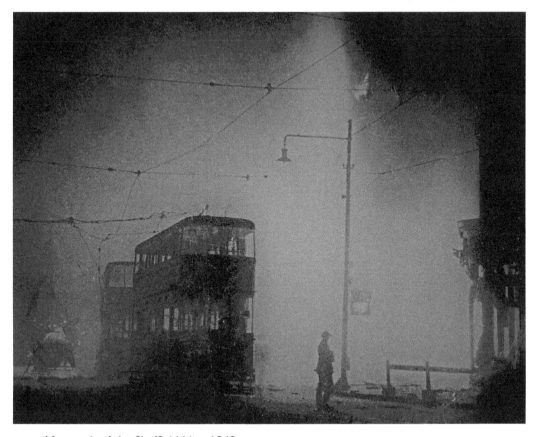

Aftermath of the Sheffield blitz, 1940.

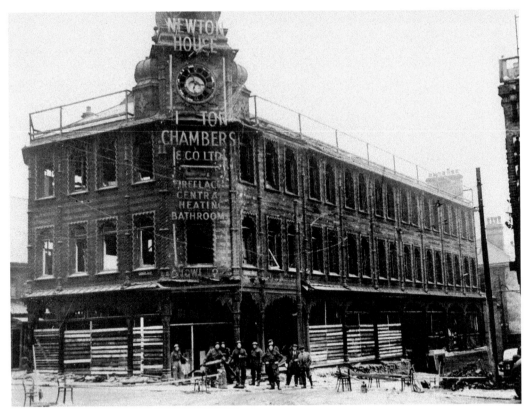

Bomb damage on the showroom of Newton Chambers at Moorhead.

to go through any armour and armour to resist any shell'. The other giant firm, Hadfield's, employed more than 10,000 workers during the war years and among their products were more than 4 ½ million shells and bombs, either completely finished or as forgings or castings, more than a million armour plates for aircraft, and no less than three million tank track shoes in silico-manganese steel.

The smaller firms also made major contributions from Darwin's, making heavy magnets for use in minesweepers to counteract the magnetic mine, and Tinsley Wire Industries making anti-torpedo nets, to Craven's, the railway carriage and wagon builders, building airframes for the Lysander reconnaissance aircraft and the Horsa glider, Osborn's making the steel hinges for the famous Bailey bridges used at river crossings where existing bridges had been destroyed and Newton Chambers making more than 1,000 Churchill tanks at Thorncliffe Ironworks. Again women made an important contribution in the Second World War, their role in the two world wars being marked in 2014 by the erection of a commemorative statue in Barker's Pool in the centre of the city.

Following the end of the war there was another boom in the light trades that lasted until the second half of the 1950s. But by this time foreign competition in the cutlery industry was biting hard. The crash in the light trades came in the early 1970s, and it was not only the small very vulnerable firms that went out of business, but also the bigger firms that had survived through thick and thin for many years. Wostenholm's were taken over by Joseph Rodgers in 1971. This combine was itself bought by Richards Brothers in the mid-1970s, but by the

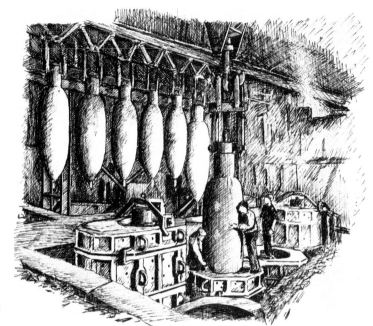

Right: Manufacturing 'Grand Slam' bombs at Vickers' works.

Below:
A reconstructed Bailey bridge over the River Don.

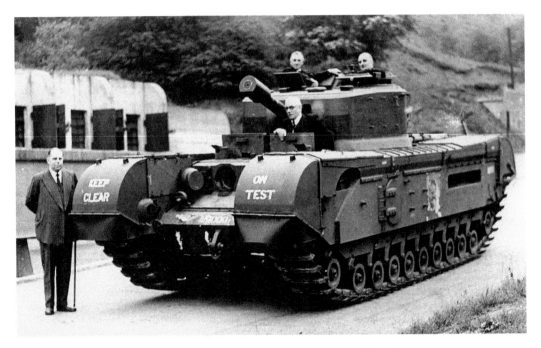

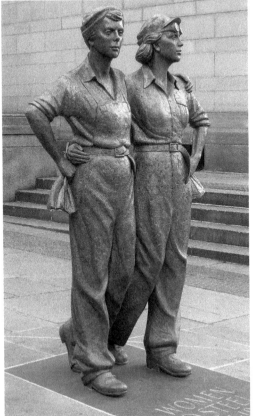

Above: A Churchill tank.

Left: The *Women of Steel* statue in Barker's Pool.

early 1980s Richards themselves were declared bankrupt. Sippel's, one of the three growing German firms in the interwar period, went out of business in 1972 and Viner's, the largest cutlery firm in the country, went out of business in 1982 – its name and trademark were sold and, shamefully, it appeared on imported Korean cutlery. The silver and electroplate companies fared no better: the well-known firms of Walker & Hall, James Dixon, Atkin Brothers and Cobb and Cooper Brothers have all gone.

In the immediate post-war period stretching into the 1950s and 1960s Sheffield's heavy steel and engineering industry remained in full production. Profits were large and there were even labour shortages. The period also saw the giant combines nationalised by the Labour government in 1949, denationalised by the Conservatives between 1953 and 1955 and renationalised by the Labour government in 1967. Through all this boom and structural upheaval, modernisation of the industry continued and Sheffield remained a major steel producer, most importantly for alloy steels for the engineering industry.

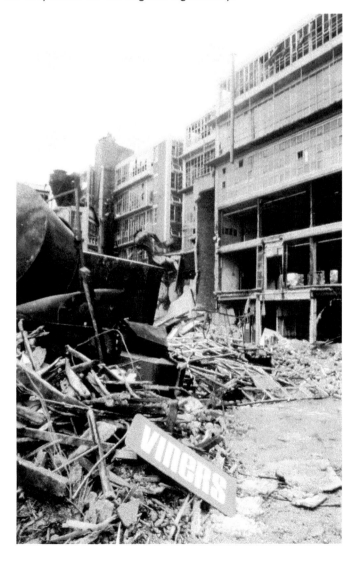

Viners' factory being demolished.

But drastic change and decline were just over the horizon. Despite the opening of English Steel's Shepcote Lane stainless plant – the biggest in Europe – in 1976, the decade saw the loss of home markets through the shrinkage in its domestic industrial customers in the shipbuilding, car and aircraft industries and overseas markets were continually shrunk through tough competition not only from its European and North American rivals, but also from Far Eastern competitors where labour costs were much lower.

The heavy steel industry's rapid decline became most severe in the late 1970s and early 1980s. John Brown's Atlas Works, opened in 1857, was closed in 1983 and Hadfield's massive East Hecla Works, opened in 1898, was closed in the same year. Employment in the Lower Don Valley declined from 40,000 in the mid-seventies to 13,000 in just over ten years; most of the residential population had already been rehoused elsewhere and nearly half the land in the valley was either cleared, semi-derelict or contained empty works. In large parts of the valley the greenfield sites of a century and a quarter earlier had now become brownfield sites. The city was in shock and the Lower Don Valley was badly in need of economic and environmental regeneration.

THE REINVENTION OF SHEFFIELD IN THE LATE TWENTIETH AND TWENTY-FIRST CENTURIES

White's *Sheffield District Directory* for 1893 listed 275 pen, pocket and sportsmen's knife manufacturers, 281 table knife manufacturers, 97 silverware manufacturers, 128 electroplate and nickel-silver makers, 225 file and rasp manufacturers, 144 saw manufacturers, 125 scissors manufacturers and 95 edge-tool manufacturers, to name only some of the many trades then in existence. By contrast, in a twenty-first-century *Yellow Pages* directory there were only 45 cutlery manufacturers and wholesalers listed, 14 electroplaters, 59 toolmakers, 23 silversmiths and 6 saw makers. Among the surviving edge-tool makers are Ernest Wright and Sons Ltd, who have been making handmade scissors since 1902. Their Endeavour Works still produce scissors for the world market. And 'little mester' ninety-one-year-old Stan Shaw has a full order book for his

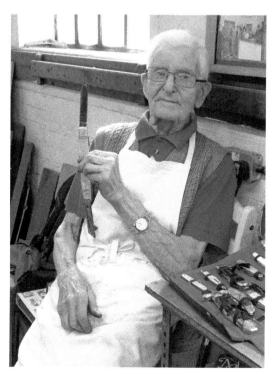

'Little mester' Stan Shaw in his workshop at Kelham Island Industrial Museum in 2017.

beautifully crafted, handmade knives. Another little mester, Peter Goss, specialises in the production of forged forceps, hip replacements and bone levers. Sheffield also boasts one of the few female knife makers in the world, Grace Horne, working in Nether Edge. And HD Sports, at their works in Rutland Road, produced the ice-skating blades of two-thirds of the figure skating winners at the 2018 Winter Olympics in South Korea and helped to bag eighteen medals in total!

Sheffield's light steel trades are *not* in terminal decline. The good name of 'Made in Sheffield' lives on in the names of cutlery and tool firms that were first established when Sheffield's light trades ruled the world, together with new firms that have come onto the scene. Burgon & Ball, for example, are makers of fifty different patterns of sheep shears (indeed the most important maker of these shears in the world) and a wide range of gardening tools. The firm has occupied the La Plata Works, on the River Loxley near Main Bridge, since 1873 but was established in 1730. They were very proud in 2017 to be awarded five stars by the Royal Horticultural Society for their trade stand at the Chelsea Flower Show. Swann-Morton, founded in 1932, export their surgical blades and scalpels used by surgeons, chiropodists, podiatrists, dentists and veterinaries, to over 100 countries. The family-run Wentworth Pewter, founded in 1947, make beautiful tankards, pocket flasks, goblets and trophies in their Darnall works, which are sold all over the world and have even appeared in Hollywood movies. And new firms such as Sheffield Precision Medical of Burngreave manufactures precision surgical equipment.

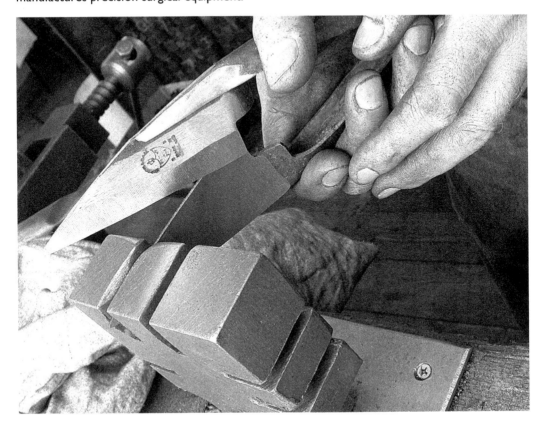

Bending shears at Burgon & Ball.

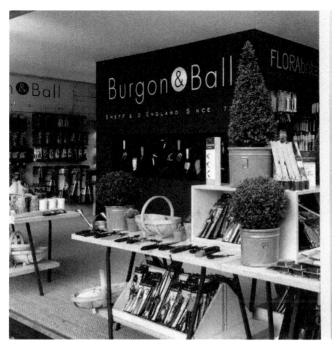
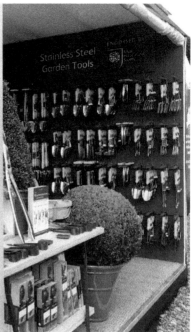

Burgon & Ball trade stand at the Chelsea Flower show.

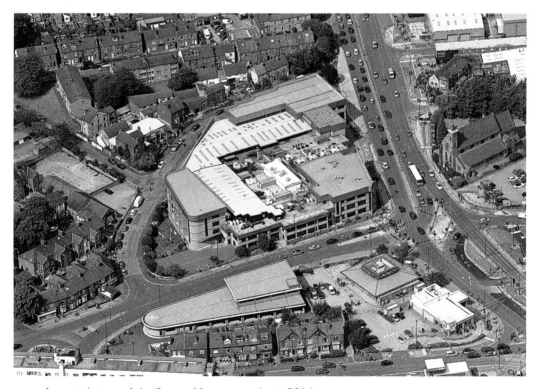

An aerial view of the Swann Morton works in 2014.

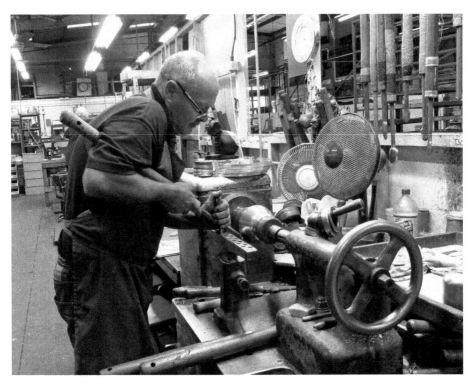

Making a tankard at the Wentworth pewter factory.

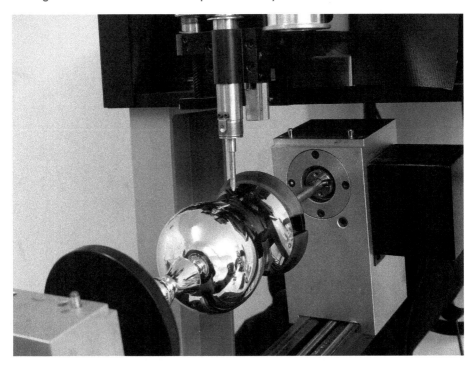

Using a computer to engrave a tankard at the Wentworth pewter factory.

Old premises have sometimes taken on a new lease of life. Take for example the Portland Works, Butcher's Wheel and Pinder Brothers. The Portland Works, now a Grade II*-listed building, was originally Mosley's cutlery works that opened in 1879 and has the distinction of being the first place where stainless steel was made commercially. It is now the headquarters of thirty-five small businesses ranging from knife makers, jewellers and a guitar maker to bespoke bike makers, a cabinetmaker and a gin distillery. Butcher's Wheel is a former cutlery and tool factory and is a Grade II*-listed building that stands in the so-called Cultural Industries Quarter. It is largely residential with the ground floor now the home of the Academy of Makers workshops (including a maker of bows for stringed instruments and a silver jeweller) and there is a gallery shop. Next door is the Sterling Works, a former cutlery works, now the Freeman College where students with complex needs, aged between sixteen and twenty-five, are taught metalworking crafts. Pinder Brothers, founded in 1877, makers of handmade flasks, tankards and a range of other stainless steel, silver-plated and pewter goods, occupy the Sheaf Plate Works on Arundel Street where there are also fourteen studios rented to modern-day 'little mesters' including a decorative cake maker, a hatmaker and a joiner. At a further three locations – the Persistence Works, Exchange Place and Manor Oaks – there are 150 artists' and makers' studios.

In the heavy steel and engineering industry the story has been one of shrinkage but specialisation. Sheffield Forgemasters International Ltd, created from the merging of some of the most renowned names in the industry and brought to the forefront of global technical innovation after a management buyout headed by Dr Graham Honeyman, is now a world

The converted Butcher's Wheel complex on Arundel Street.

Sarah Waterhouse's fabric workshop at the Persistence Works.

The studio of Andrew Heath, painter and mosaicist, at the Persistence Works.

leader in the production of highly complex, safety-critical castings and forgings. It now supplies key international industries including civil nuclear power, defence and offshore oil and gas exploration and manufactures some of the world's largest single-piece steel castings. Liberty Steel (formerly Samuel Fox's and Tata Steel) at Stocksbridge produces special steels for the aerospace, oil and automotive industries. Recently another Sheffield engineering firm, SCX, has completed the second year of a three-year project to construct a foldaway roof for No. I Court at Wimbledon – they constructed the roof on Centre Court in 2009. They are also manufacturing a retractable football pitch for Tottenham Hotspur. Some of the specialised engineering firms that can trace their origins back over centuries also continue to thrive. Doncasters Bramah, for example, of the Holbrook Works, Halfway, was founded in 1778. It employs around 250 people and manufactures Rolls-Royce engine parts, exhausts for CFM jets and helicopter rotor blade protectors. And these are just a few of the current success stories – Outokumpu, Prior Marking Technology, Mayflower Engineering and Abbey Forged Products are also expanding and supplying a world market.

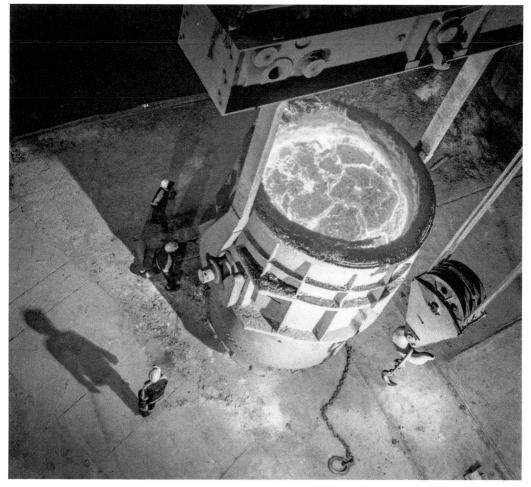

A 90-ton ladle of molten steel at Sheffield Forgemasters' melt shop.

One of the most significant developments has been the establishment of the 100-acre Advanced Manufacturing Park at first on a site in Rotherham but now extended into Sheffield and only 2 miles from Sheffield city centre. The park provides facilities for high-tech companies, for example Rolls-Royce, that manufacture products for precision industries such as aerospace, gas, oil and nuclear industries. The park is the home of the University of Sheffield's Advanced Manufacturing Research Centre founded in 2001 and which conducts both generic research and specific research for individual companies. It employs over 700 and was influential in attracting McLaren and Boeing to the Advanced Manufacturing Park.

Today Sheffield can be called a post-industrial city. The metal trades still thrive (as outlined above) but more and more people work in other types of business: in retailing, health, commerce, banking, education and research. The Lower Don Valley, an industrial wasteland in the 1970s, is now crowded with edge-of-town shopping, entertainment and sporting

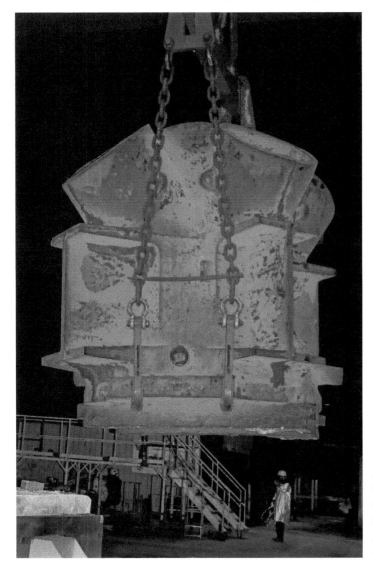

A structural casting for offshore oil and gas exploration undergoing heat treatment at Sheffield Forgemasters' foundry.

The old Samuel Fox building, now Liberty Steel, Stocksbridge.

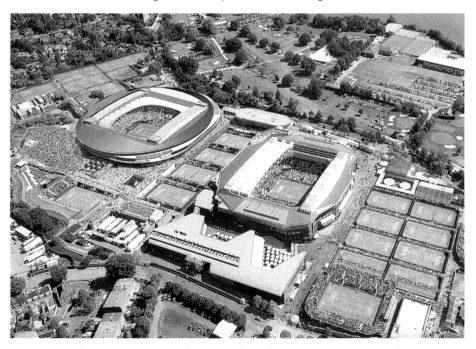

Aerial view of the retractable roof at No. 1 Court Wimbledon (back) and Centre Court (front), manufactured by SCX. (Copyright AELTC/KSS Design Group/SCX)

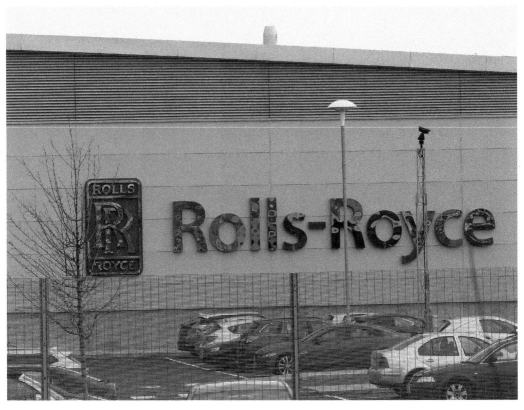

Rolls-Royce factory in the Advanced Manufacturing Park.

destinations: Meadowhall Shopping Centre, which had a £62m upgrade and refurbishment completed in 2017, attracts 30 million visitors a year; the Valley Centertainment complex with its restaurants, bars, cinemas and bowling alley; Sheffield Arena, with its audience capacity of 13,500; iceSheffield with its two Olympic-sized ice rinks; and the English Institute of Sport. The area also contains a technology park. The Heart of the City scheme has also helped to modernise the city centre, at the heart of which are the Winter Garden (which has a Sheffield Makers' shop), the Millennium Galleries and the four-star Mercure St Paul's Hotel. The long-awaited Sheffield Retail Quarter project (renamed Heart of the City II), which will see the central retail/entertainment area extend southwards towards the new market hall and the existing Atkinson's department store on The Moor, is now beginning to take shape. And at opposite ends of the city are two other modern edge-of-town shopping developments: Crystal Peaks in the south-east opened in 1988, and Fox Valley opened in 2016, the latter on the site of part of Samuel Fox's original Stocksbridge Steel Works, in the north-east.

Brewing has also seen a resurgence. Once the home of large breweries such as Gilmour's, Stone's, Tennant's and Ward's, which have now all disappeared, their places have been taken by real ale breweries such as Abbeydale Brewery, Bradfield Brewery, Kelham Island Brewery and Sheffield Brewing Company and the city now has a national reputation for its craft ales. There is even a Sheffield Ale Trail and according to CAMRA Sheffield is reputed to be 'the beer capital of the world'. Kelham Island Tavern was joint winner in CAMRA's Yorkshire Pub of the Year in 2017.

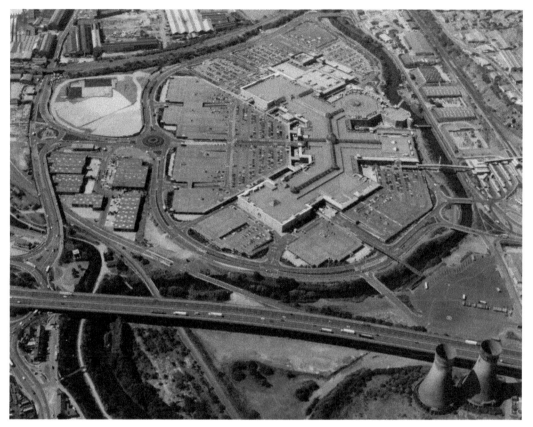

Aerial view of Meadowhall Shopping Centre showing the extensive car parking facilities.

New additions to the economy or expansion of existing sites or companies are announced on an almost weekly basis. A 'sustainable industries park' is planned for a brownfield site in the city and national law firm Irwin Mitchell is to build a new £20m headquarters in the city. The banking giant HSBC, which originally moved part of its headquarters from London to Griffin House in Sheffield in the late 1970s, is to move its staff, numbering more than 2,500, to a new central site in 2019 containing 140,000 square feet of office space on the site of the former Grosvenor Hotel. And between 2011 and 2017 there was a 27 per cent increase in the number of digital high-tech businesses, which now number almost 5,500 and more than 12,500 people are employed in the digital/technology sector in Sheffield. The largest twenty-five companies have a combined turnover of just under £2bn. Among the newest centres of the industry is the Electric Works on Pond Street, the home of digital and media enterprises. And Castle House, the old Co-operative store in Angel Street, is to be converted into a 'tech hub' capable of employing 1,000 people.

Sheffield's two universities attract more than 60,000 students to the city every year. Yet forty years ago there were only 4,000 university students in Sheffield compared with 45,000 workers in the steel industry. These figures have now been completely reversed. The University of Sheffield has 28,000 students in attendance, more than 8,000 of whom are postgraduate students. Faculty of Science staff and students have included six Nobel prize-winners since 1945. Sheffield Hallam University, which was formerly Sheffield

Interior view of the new market hall on The Moor.

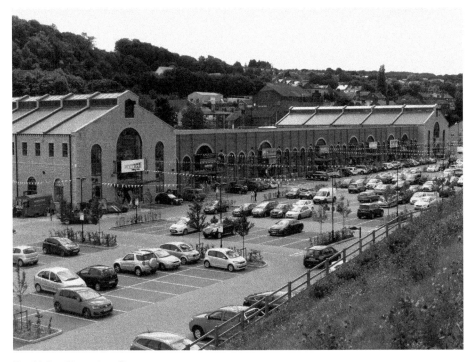

Fox Valley Shopping Centre.

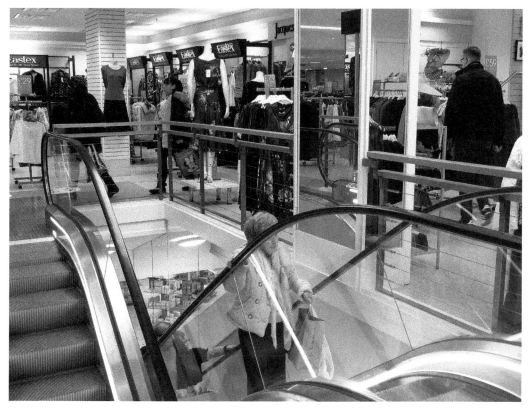

Interior of part of Atkinson's department store on The Moor.

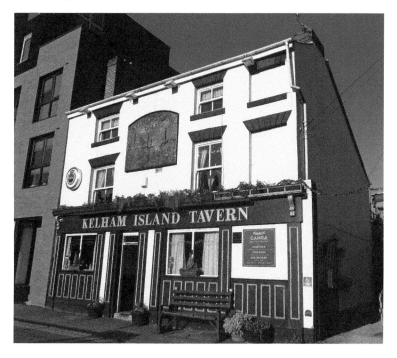

Kelham Island Tavern.

The Electric Works.

City Polytechnic, gained university status in 1992 and now attracts more than 30,000 students a year to the city, nearly 4,500 of whom are international students. The vice-chancellor reckons these students contribute £400m a year to the local economy. Sheffield Hallam University has a staff of nearly 3,000. Sheffield also has two university technical colleges (UTC) for post-fourteen year olds.

In the countryside Our Cow Molly dairy farm, farm shop and ice-cream parlour at Dungworth, continues to expand and now supplies milk and ice cream throughout the city. The Thompson family of Povey Farm, near Norton, was awarded the *Yorkshire Post* Farmer of the Year award in 2017 for their enterprising pig farm, supplying supermarkets and farmers' markets with their pork. What is more, Sheffield has recently been awarded the accolade of the 2017 winner of the *Luxury Travel Guide* 'emerging city destination of the year award for Europe'. It was praised for its quirky cafés, independent shops in former steelworks, world-class museums and acres of rolling countryside. This countryside contains nearly eighty ancient woodlands, with one 300-acre wood, Ecclesall Woods and its Woodland Discovery Centre, within a 15-minute drive of the city centre. And otters have returned to the River Don, which fifty years ago was reckoned to be one of the most polluted rivers in Europe.

Monuments and memorials to Sheffield's industrial might dot the city landscape. There are figures in relief on the façades of the Town Hall and the White Building in Fitzalan Square, a statue of crucible teemers greets shoppers at one of the entrances to Meadowhall Shopping

The University of Sheffield Arts Tower.

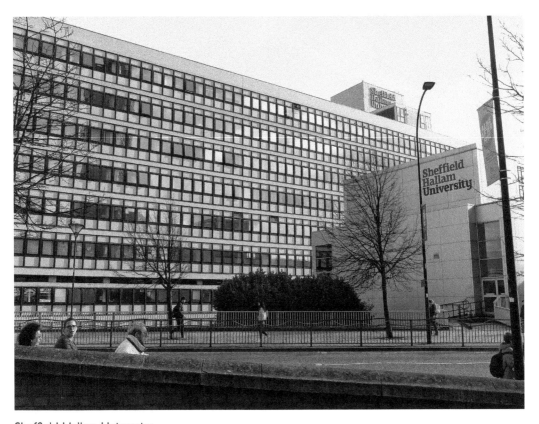

Sheffield Hallam University.

The shop at
Our Cow
Molly.

The Woodland Discovery Centre, Ecclesall Woods.

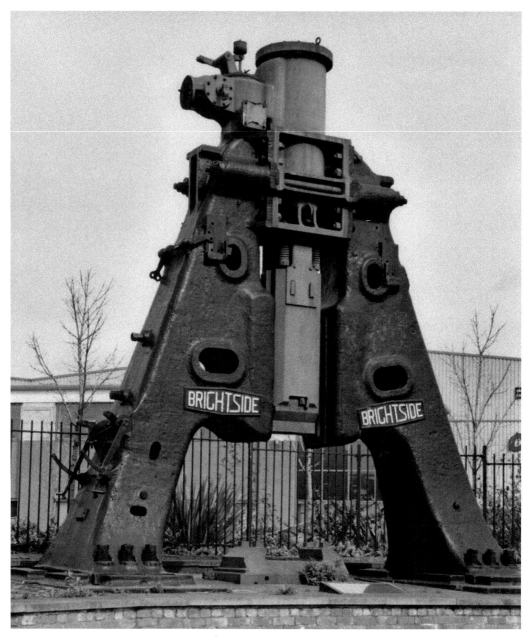

The 5-ton steam hammer, built by Brightside Engineering Company in 1947, now standing at the junction of Savile Steet East and Sutherland Street.

Centre, the Women of Steel statue graces Barker's Pool, and Shepherd's Wheel and Abbeydale Industrial Hamlet are industrial museums. In the Lower Don Valley stands the former entrance to Thomas Firth's Siemens Department and a 5-ton steam hammer towers over Savile Street East. And the 'Man of Steel' stands on the edge of Bowden Housteads Wood, celebrating the connection between charcoal and steelmaking. But the most interesting and unique 'monument' in the Lower Don Valley is the biggest population of wild figs anywhere in Britain. They are well

The *Man of Steel* statue by Jason Thomson in Bowden Housteads Wood.

established on the banks of the Don between Attercliffe and the Tinsley Viaduct carrying the M1 motorway and at one point form a small wood. They originated in sewage during storms when the sewers overflowed. And they thrived because of the microclimate that developed because of the warm water discharged into the river by neighbouring steelworks in the past. They are living monuments to a rich industrial history and have been designated a locally protected species.

Wild figs beside the River Don.

BIBLIOGRAPHY

Anon, *Sheffield and Neighbourhood* (Pawson & Brailsford, 1926).

Barraclough, K. C., *Sheffield Steel* (Moorland Publishing Company Ltd, 1976).

Derry, J., *The Story of Sheffield* (Sir Isaac Pitman & Sons Ltd, 1915).

Gatty, A., *Sheffield Past and Present* (Thomas Rodgers and Bell & Sons Ltd, 1875).

Hey, D., *A History of Sheffield* (Carnegie Publishing, 1998).

Hunter, J., *Hallamshire: the History and Topography of the Parish of Sheffield* (1819 and revised by A. Gatty, Virtue & Company, 1873).

Jones, M., *The Making of Sheffield* (Wharncliffe Books, 2004).

Jones, M., *Sheffield: A History & Celebration* (Francis Frith Collection, 2005).

Jones, M., *Sheffield's Woodland Heritage* (fourth edition, Wildtrack Publishing, 2009).

Leader, R. E., *The History of the Company of Cutlers in Hallamshire* (Pawson & Brailsford, 1905).

Pollard, S., *A History of Labour in Sheffield* (Liverpool University Press, 1959).

Vickers, J. E., *A Popular History of Sheffield* (EP Publishing Ltd, 1978).

Walton, M., *Sheffield: Its Story and Its Achievements* (The Sheffield Telegraph and Star Limited, first edition, 1948).

ABOUT THE AUTHORS

Husband and wife team Mel and Joan Jones have co-authored more than twenty books on the local and landscape history of South Yorkshire. These include Amberley titles *Ecclesfield, Chapeltown & High Green Through Time* (2009), *Thorpe Hesley, Scholes and Wentworth Through Time* (2012) and *Ecclesfield, Chapeltown & High Green From Old Photographs* (2014).